ALEX KATZ by ANN BEATTIE

ALEX KATZ

by ANN BEATTIE

Harry N. Abrams, Inc., Publishers, New York

EDITOR: ANNE YAROWSKY
DESIGNER: SAMUEL N. ANTUPIT

Excerpt, page 29: Published in the *New York Times,* 1976.
Copyright © 1976 by Joan Didion. Excerpt, page 40:
From DUBLINERS by James Joyce. Copyright © 1916 by
B. W. Huebsch. Definitive text Copyright © 1967 by
The Estate of James Joyce. Reprinted by permission of
Viking Penguin, Inc., and The Society of Authors as the
literary representative of The Estate of James Joyce. Ex-
cerpt, page 74: From the introduction by Susan Sontag
to CERTAIN PEOPLE: A BOOK OF PORTRAITS by
Robert Mapplethorpe. Copyright © 1985 by Susan Son-
tag and Twelvetrees Press. Reprinted by permission of
Farrar, Straus and Giroux, Inc.

LIBRARY OF CONGRESS CATALOGING-IN-PUBLICATION DATA
Beattie, Ann.
Alex Katz.

1. Katz, Alex, 1927– —Criticism and interpretation.
I. Title.
ND237.K33B4 1987 759.13 86-17360
ISBN 0-8109-1212-0

Published in 1987 by Harry N. Abrams, Incorporated,
New York. All rights reserved. No part of the contents
of this book may be reproduced without the written
permission of the publishers.

Times Mirror Books Printed and bound in Japan

Contents

List of Plates

14. UP IN THE BLEACHERS. 1983.
 Oil on canvas, two panels, each 12' x 8'; overall 12' x 16'.
 Courtesy Marlborough Gallery, New York

15. THE GRAY DRESS. 1982.
 Oil on canvas, 6'½" x 15'.
 Collection Stephen L. Wald, New York

16. SUMMER TRIPTYCH. 1985.
 Oil on canvas, three panels, each 78 x 48"; overall 78 x 144".
 Courtesy Marlborough Gallery, New York

17. THE TABLE. 1984.
 Oil on canvas, 6' x 12'.
 Courtesy Marlborough Gallery, New York

18. THE YELLOW HOUSE. 1982.
 Oil on canvas, 78 x 72".
 Collection Paul Jacques Schupf

19. THE YELLOW HOUSE. 1985.
 Oil on canvas, 7'11¾" x 9'.
 Courtesy Marlborough Gallery, New York

20. ROGER AND SOPHIE. 1981.
 Oil on canvas, 71⅜ x 50¼".
 Courtesy Marlborough Gallery, New York

21. BATHERS. 1984.
 Cutout: Oil on aluminum, 65 x 45".
 Courtesy Robert Miller Gallery, New York

22. RED AND LIZZIE from PAS DE DEUX. 1983.
 Oil on canvas, five panels, each 11' x 6'; overall 11' x 30'.
 Collection Paul Jacques Schupf

23. ANNE AND BILLY. 1981.
 Oil on canvas, 60 x 60".
 Private collection

24. THE THAI RESTAURANT. 1980.
 Oil on masonite, 15 x 22".
 Private collection

25. JOHN AND ROLLINS. 1981.
 Oil on canvas, 48 x 96".
 Courtesy Marlborough Gallery, New York

26. OUR EYES HAVE MET. 1979.
 Oil on canvas, 78 x 84".
 Courtesy Robert Miller Gallery, New York

Editor's Note

For many years I have been an avid admirer of the work of Alex Katz and of Ann Beattie. Each has satisfied particular cravings of mine in the areas of painting and in fiction writing. As an editor, I have struggled to find a way to combine these two personal passions in my daily work, but mostly I have enjoyed each art form separately, working Harry Abrams and SoHo by day, reading nineteenth- and twentieth-century novels by night. Slowly, however, the idea emerged that the two *could* be brought together somehow. What would it be like, I wondered, to pair a painter and a fiction writer whose individual artistic sensibilities seemed joined or connected by common concerns and techniques? What would occur if a writer were asked to examine the work of a painter of like imagination without the constraints of art historical reference or criticism (much less a working knowledge of either) and approach the work with only a canvas full of images in front of him or her? I remember walking into the Metropolitan Museum of Art in New York one afternoon in 1983 to see the great Manet show and being struck by a lone, intense figure standing in front of Manet's *Lady with Fans.* It was Philip Roth, and he was clearly lost in the picture. I wondered what this storyteller was thinking about as he stared at it. He seemed as consumed by the image in front of him as he might be by a vivid passage in Tolstoy. What stories was he spinning as he looked at this portrait of Nina de Callias?

A year or two passed, and I too found myself staring—this time at a Katz print that hangs in my bedroom. I was trying to make out who the five women might be who were pictured there—each was shown only from the head up—and I unexpectedly found myself thinking about the people in Ann Beattie's short stories and

novels. Soon afterward, and with little more than this passing coincidence or hunch to guide me, I approached both Katz and Beattie and asked each if they knew of the other's work (they did) and if a book might not be created out of such a juxtaposition. Their responses were immediate, and they agreed enthusiastically to the project.

At lunch in SoHo, not far from where Katz lives, they were introduced, and, perhaps not so surprisingly, the rapport between them was instant and obvious. There followed a series of meetings between Katz and Beattie and between Beattie and some of the people Katz has painted. It was up to Ann to choose the paintings she wanted to write about—a selection based largely on works from the 1980s—and to decide how she wanted to write about them. Alex and I had no idea of the form her response would take until the finished manuscript was in our hands. What did emerge from Ann is not quite fiction, but for anyone familiar with her work, the essay she has written here is clearly a by-product of it. As we are made to look anew at Katz's work, we are also forced to look at Beattie and at the underpinnings, I believe, of her fiction.

For both artists, the experience has turned out to be eye-opening, and very exciting. It has taken courage for Ann to step out of the literary world to confront the art world, and it has taken a kind of daring openness on the part of Alex to allow an observer not weaned on Janson to explore his work before the public and to be challenged by a vision of it not put to him (or the public) before.

What follows, then, is not only the result of this unusual enterprise, but a provocative, sometimes startling tribute to them both.

<div align="right">A. Y.</div>

A Reading of Alex Katz

Alex Katz is painting in a time when we have become used to myopic perceptions. Our sense of time has been fooled around with, and we have grown used to examining things by staring: freeze-frames, instant replays, evaluations quickly arrived at within the fallacious concept of stopped time. Because of modern technology, it is our tendency to observe process at the same time we are moved by content. It has been a special problem for figurative painters in this part of the twentieth century to puzzle out how to acknowledge the so-called real world (thought of, generally, as accessible through scientific analysis) so as not to appear naive, impervious, or isolated. Alex Katz says that he paints what catches his eye—but of course the eye that focuses is a particular eye. On the most pedantic level, we all must wonder each day how much detail defines us and how much complicates unnecessarily.

Intuitively, the painter has to respond quickly to the environment. Katz says that he is not interested in the psychology of his subjects when he paints them, or interested in what they think after the fact. What he takes for granted when he says this is that he is, of course, subjective, and that subjectivity is informed by some spirit that is partly instinctual. It is no small step to presume to re-present reality. If his primary interest is in surfaces—in light, color, and texture—it is nonetheless true that he is drawn to particular landscapes and figures where these factors register, instead of demonstrating those factors as they register on abstractions. A model's earring

might seem more tantalizing than it really is because Katz is continually going after versions of things: he is not attempting to be a photographer with paint. What is amazing is that he often captures the essence of something so sparely. We *do* know where the light falls when we look at one of his canvases; the brushwork can be amusing and editorial (the sky in LINCOLNVILLE ALLEGORY; the skin in so many of the portraits, which looks airbrushed)—but the immediate effect is just that: a sudden registering of something that we instantly take to be real. We spring to it as if we were reacting to a flash card. Time and again we react to his images with an instant shock of recognition, yet continue to be drawn in because we are staring at something that is, inevitably, mysterious. And Katz's mysteries resist paraphrase.

Katz seems so forthright in what he does—so consistently to be a painter who paints without unnecessary complication—that the art of it may at first be misunderstood. Situation is almost always immediately accessible: in SUMMER TRIPTYCH, three couples walk near the woods; in HIROSHI, a man stands with his back to the window; in THE RYAN SISTERS, four girls take a stroll down a road. Each of these situations is certainly ordinary, unthreatening—but each should not be thought of as simple or unchallenging beyond the first sensory impression. The archetypes, the variations of context, the enigmatic or mysterious expressions make them more of a puzzle, finally, than they first appear. They are not big problems to be solved—rather, they are simplifications that point out complexities. So stark and simple that they are undeniable, it may take a moment for us to admit our fascination or—as often—our disquiet.

As with all art, something general must radiate from the particular. Yet with Katz the particular person or place can seem so transparently real, such an end in itself, that the viewer is left without a vocabulary to generalize. The temptation may be to project or to imagine scenarios that precede or take place during or after the moment of the painting—whether or not we look at art, we live in our own narratives anyway. Katz, more than most contemporary figurative painters, confronts us, then, with a bit of a problem: what to say about the undeniable.

No one who looks at Katz's paintings could say that they are the artist's imaginings. They are too uncompromising to be misperceived as that: he comes in too close, the way a photographer moves in on his subject; he keeps things simple enough so that you need to stare to see what the variation is, what importance is inherent in what he is painting, technically, so well. And although you rarely feel you can make eye contact with his subjects or engage with them, Katz would say that such interaction is not much to the point. He is happier talking about the impetus that directs his sensibility—the way light strikes the surface and the way paint is applied—than

11

he is critiquing what emotions his subjects display in the paintings. Yet it is only after some examination that the real importance becomes apparent: that whether or not the painter intends a psychological dimension, it is there, and that he is providing us with an opportunity to study human nature.

While it is often assumed that Katz is painting ordinary life, the paintings are neither versions of ordinary life that we can be comfortable observing, nor can we enter into them. They are not the equivalent of looking into the mirror, but rather things that we look at and see moments for which we are provided with no history. There seems nothing conditional about his people. Though it is difficult to explain, there is some rooted quality to many of his subjects: we do not have the feeling that we are meeting these people in just any moment of time. They seem to have evolved in some direction before the moment in which they were painted, to already have worked out some particular dynamic. These are not people in a state of change, but in stasis. This sort of freeze-framing presents people in action, or at odds with themselves, or off-kilter, or having an awkward moment; they are not caught on the run or gnawing their nails. The essence of their selves, in the present moment, is what is caught. In LINCOLNVILLE ALLEGORY (plate 9), Ada has come to the point to which she has come. She may be taking a break from eating French fries, or she may be about to rise and go home—we can invent any sort of story to "explain" her—but the temptation is not to do that. It is more tempting to take her, or the couple in THE THAI RESTAURANT (plate 24), the way we would a statue: as something that radiates from what it is, not from what it has been or from what it will be. If something seems inevitable it does not invite much speculation. Yet without our usual way of categorizing and understanding, we may be a little uneasy. On some level, we all want stories to be our stories: we want them to be familiar enough to verify us. We are uncomfortable when they do not. And Katz's paintings of seemingly ordinary people doing the things of ordinary life do not reinforce any optimism about the ease of daily life. At best, as in LINCOLNVILLE ALLEGORY, it remains neutral, familiar territory—we know no more about this vacation spot than we did before we saw the canvas—and at worst there are threats to our ideas of happiness, composure, and harmony.

It is difficult to look at some of Katz's paintings and not imagine that there must have been times when his powers of observation pained him. Though we are more likely to think of a painter such as Eric Fischl, who seems to be peeking at his subjects enacting something that is obviously—or potentially—shocking, and who transforms ordinary surroundings into contextual definitions of people as a social interpreter, Katz has—in a naturalistic, yet stylized way—defined, perhaps equally disturbingly, some constants about the quality and texture of contemporary life. With

Fischl, the near-mythic meets the new age, and we confront a vision in which complexity evolves from juxtapositions meant to shock. Katz, on the other hand, doesn't augment what he does or suggest a story line based on surface conflict. His work is sparer and, one senses, of some moment removed from time. And because his imagery is recognizable, we feel instantly comfortable or uncomfortable—convinced or skeptical.

Or we might feel both things at once. For as soon as we are drawn to the recognizable, we sense, too, that some other element is present—that seemingly conventional images are not so conventional at all. When a little girl in shorts and a shirt sits, at dusk, on the white chevron of a raft, we see, almost as soon as we accept that it is a child at rest, a forest so startling it seems that darkness itself has been personified: the monolith of darkness is so all-pervasive that it almost crowds out the sky. While the child may be oblivious to its presence, the way Katz has captured darkness changes our sense of the scene we are looking at and, ultimately, our sense of the world. TRACY ON THE RAFT AT 7:30 (plate 1) is complicated because it reinforces the recognizable, likable quality of an ordinary person in an ordinary situation, yet at the same time suggests another world, composed of layers of darkness over layers of darkness—a notion more metaphorical than literal.

Similarly, for all its simplicity, HIROSHI (plate 2) becomes a portrait with implied editorial comment. It asks us to think something—perhaps, even, to figure something out. The domino lights in the nighttime world behind Hiroshi suggest a geometry and precision as well as sketchily represent the polarities of light and dark. Backed up against a window, Hiroshi's suit is dark, his tie is dark, his eyebrows and hair are dark (protective coloration?). But there is no expression that tells us what Hiroshi feels, or even whether he is aware of the lights that glow behind him. Like Tracy, he does not move in the world that surrounds him. We know what he has turned his back on, but not what he looks toward. And because the focus is on Hiroshi alone, we have to understand that he is among them (the people who inhabit the lighted rooms outside), but not of them—literally not of them, because there is no *them*. The world where there is other life has been banished, relegated to the symbolism of geometric form. And what does this tell us about Hiroshi? That he senses himself in a solitary state? That he is by definition formidable, worth looking at, because he is the only representative of a world that is only an abstraction if someone does not turn on the lights and do the work? The world reflects him, and he reflects it (light shines on his shoulders), yet what his situation is we can only guess at.

Though Katz often places people in an environment, as he does in HIROSHI and TRACY ON THE RAFT AT 7:30, it is not an environment that can be relied on to tell

us something about them. Furthermore, his subjects do not interact with the environment. What they *do* do is exist more as part of the whole than might first be apparent. Consider two portraits of Joan, painted in 1974 and 1984 (plates 3, 4). The 1974 painting shows her posed by a window—a background often used in Katz's work. There is only slight shading to suggest the building or buildings outside. It seems that this Joan could not be part of that world: she is too gazellelike, too fragile, too mysterious, with her large eyes downcast and her hair softly painted. Our eyes are riveted by the bare skin. Everything seems very tactile here: the wispy hair, though it spikes forward a bit as it curls, is all the more human in contrast to the pointed leaves of the snake plant; the rigid vertical and horizontal lines of the window make an impersonal pattern that Joan stands in contrast to as she inclines forward, her back turned on the world behind her. The background is a bit ominous here: the snake plant, the cactus, the harsh black lines of the window. Even if she were not seen in contrast to such things, she would be lovely. The necessity for including them in the painting may suggest a symbolism beyond the obvious phallic connotations of the plants. Katz has deliberately altered his depth of field so that he gives the impression that Joan and the plant rise almost as one entity from the same spot. Yet clearly there is no relationship between the woman and the plant—it is merely that an irony is suggested by the plant's presence, and that its harshness reinforces her softness and otherness. Here, and elsewhere, backgrounds are uncomplicated (when they are detailed at all), and there is no interaction between the person and what we see of what is, at least at the moment, that person's world.

14

In this view of Joan, we see her in opposition to the world around her. We know her by contrast. The plants are unpleasant—stiff or prickly—and in our emotional response to the subject, we are like the knight who sees a damsel in distress. It is difficult to look at this painting without having a strong emotional response. In her own right, Joan is desirable, but by contrast to the plants, her sexuality is emphasized at the same time it conveys a vulnerability. She and the plants have nothing in common: they are phallic, she is female; they are plants with hard surfaces, she seems touchable. As in THE THAI RESTAURANT, the plant's presence helps to define the people. In THE THAI RESTAURANT, the plant provides a fountain-fall of delicacy, in front of which the couple looks more stolid; in JOAN, 1974, the plants provide an ironic subtext for the painting and accentuate the essence of the subject.

Ten years later, seen without background (plate 4), Joan's expression is quite different. Her eyebrows are stylized by Katz, but her lipstick is painted on. She still seems touchable—but less so. Seen closer up, in profile, she has the position of ease. She is not revealed or betrayed by anything, and her world—or the painter's world—

has been dropped out. When the viewer tries to engage with her, though, it is impossible. One can only look—and she seems at once so simple, so simply presented, and yet so mysterious—and try to understand by fixating on the image itself, looking deeper into it. Then the pinpoint pupils seem the glass eyes of a doll, the expression comprehensible but giving us no specific information with which to understand her, and the hand begins to draw the eye away—a hand painted as if the fingers incomprehensibly and shockingly disappear into her hair with impossible regularity; the line of demarcation might as well have been drawn with a ruler—or scissors might have been used to snip off the fingertips. Because of the way Katz has painted the partial fingers, the question arises: what if there is no hand beyond what we see? What if there is something really missing? And as the hand becomes, possibly, something else, so our perceptions of Joan are called into question. We are reminded of the arbitrary exactitude of art, that the painter is there, present as a trickster. Yet the half-hand does not really work as a joke, but as a disturbing image, a hand and not a hand. What should we believe? That the eye will fill in what is missing? That everything is all right? That the fingers' disappearance has no connotations that pertain to the whole? It is a discordant enough presentation to make us uneasy; she is both the soft, tactile Joan of ten years earlier, with whom we cannot quite make contact, and someone depicted by the painter's imagination as missing, in part—imperfect, captured, and interpreted by his vision. While the background does not provide a comment, Katz's approach does. Joan cannot be easily gotten at. In spite of what she resembles as an archetypally pretty woman, she is so still that we might be studying a mask. Though Katz has come in closer with his perspective, he has only intensified the kind of ironic distance we feel from Joan. And if we might ever have been at ease, or if our eye might have left her face too soon, he has interpreted some aspect of her with the strange raised hand, just as he subtly explained her years before by putting her in what he meant to be seen as a real context.

It is interesting that in Katz's paintings people do not relate to such familiar props as plants—no finger ever touches a leaf—and that the background seems irrelevant to the people's emotional states. Whatever is there is there (difficult to believe that Joan would own such plants, or that the painter would have gone to pains to import them for the sitting), but it is something that conveys meaning to the people who look at the paintings, not to the subjects themselves.

Many times, the subjects' attitudes do not seem contingent upon the context in which they are portrayed. We sense that whatever they are thinking, it does not have much of anything to do with the present moment. And by dropping out details—substantiating details, such as food on a table, or cups of Coke in the bleachers—Katz

makes us look more starkly at people's positions without props. Their emotional states may not be ambiguous, but what made them arrive at that point certainly is. To some extent, we must fall back on our own understanding of people to try to intuit what the subjects are feeling. The subjects are often large, seen from close perspective, frozen in time, and calm (Lizzie in RED AND LIZZIE, plate 22, being a notable exception).

Look also at Ada in ADA AND FLOWERS (plate 8). She is painted in close-up, with her face rising out of the lilies, daisies, and field flowers. This is a mock-romantic presentation, a portrait that reminds us of Rousseau's jungle beasts who randomly poke their heads through lush vegetation. One wonders what Ada is doing there, her head like a balloon held on by too short a string, looking straight ahead, but focusing neither on the flowers nor on the painter or viewer. We have only this fact: that she exists in close proximity to a bunch of flowers, and that somehow—again—they inform our sense of her, and she of them. The subtle visual link is between her lips and the pink flower at the side of her chin. A pretty woman behind a bouquet is hardly a radical image, but consider the way it is difficult to say whether the face or the flowers predominates; why she is seen so close to them, and yet expresses no involvement; and, again, what depths she holds that her eyes, cast on some vanishing point we do not see, mysteriously suggest.

Finally, of course, what holds our curiosity is not that we have been given the opportunity to analyze an attractive woman and some pretty flowers, but that we know from experience that there is a narrative that has not been spelled out for us. The Ada of this painting has to be a particular person to have cared to gather the flowers. As is usual with Katz's portraits, the tendency is to see them as the last frame rather than the first—to feel that we are looking at something that is a fait accompli—to have the sense that some action is over and some attitude arrived at. Ada might be an icon at an altar, history having passed, so that now what we see represents something; the present implies a past. Also, with her serenity (why not read it that way, instead of passivity) that transcends the moment, Ada often functions as an archetype, with beauty banked around her, or even as the incarnation of beauty. Loveliness is a fact of this painting, and individual physical beauty and the beauty of the natural world cohere.

Katz has often selected his subjects from a rather sophisticated group of fellow artists (Jennifer Bartlett; Rackstraw Downes; Rudy Burckhardt; Francesco Clemente, among others) who would grant him his right to process and who tend to understand what he is up to to begin with. "You are not posing for Alex other than as a dancer," Rackstraw Downes says. "I was not a person. You are in some role where you are taking some visual position for him: a body position....I never felt my personality re-

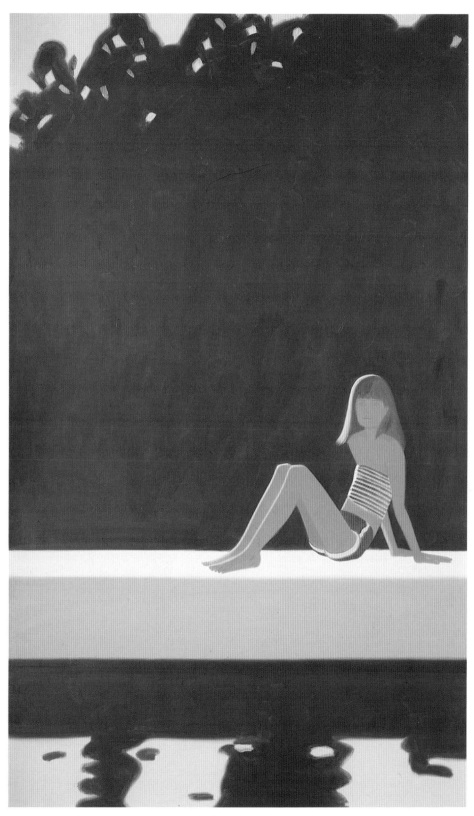

1. Tracy on the Raft at 7:30

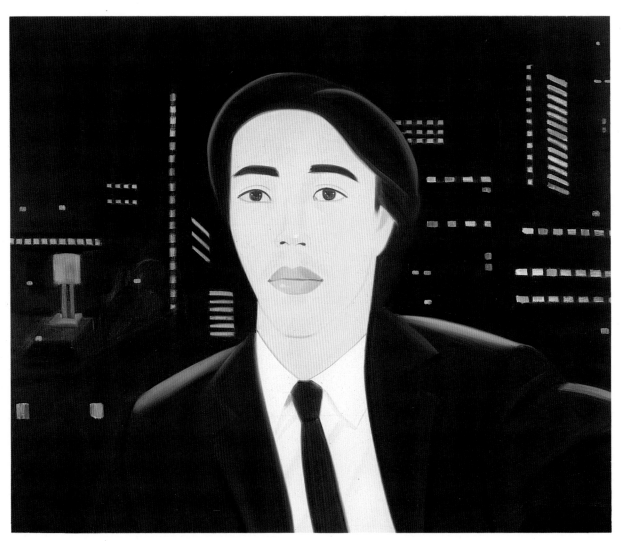

2. HIROSHI

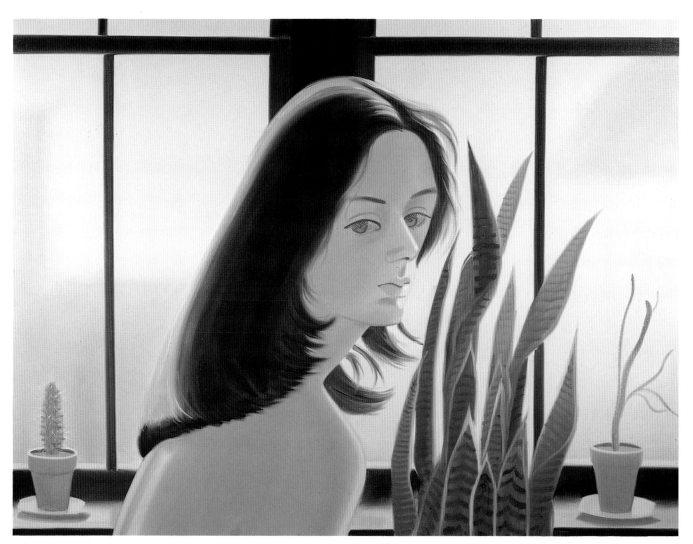

3. JOAN (1974)

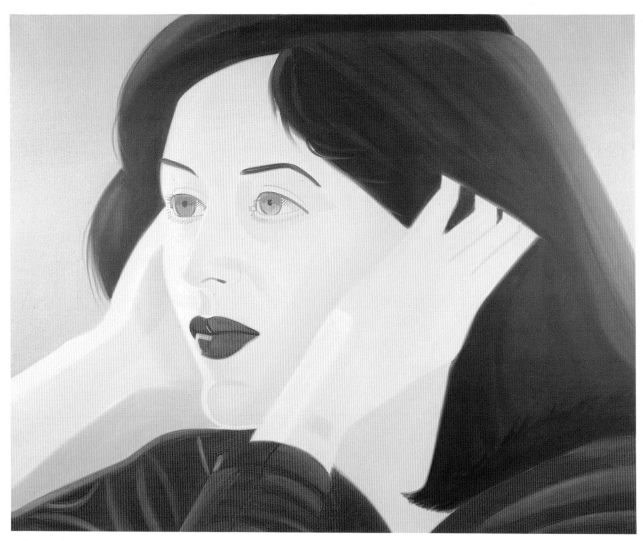

4. JOAN (1984)

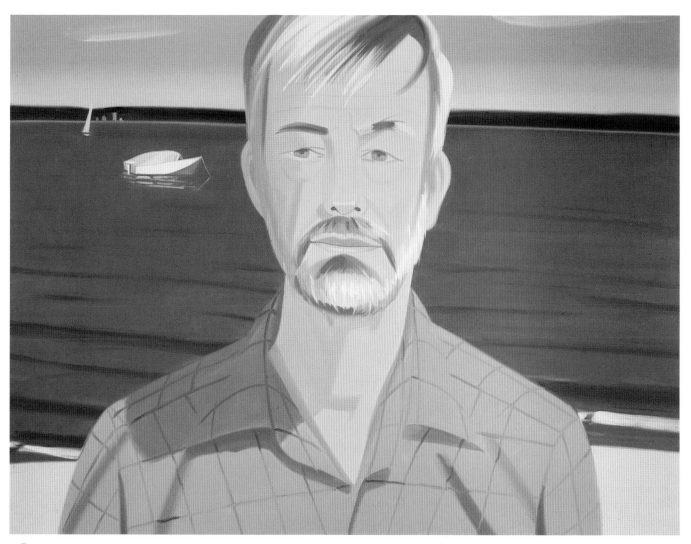

5. RUDY

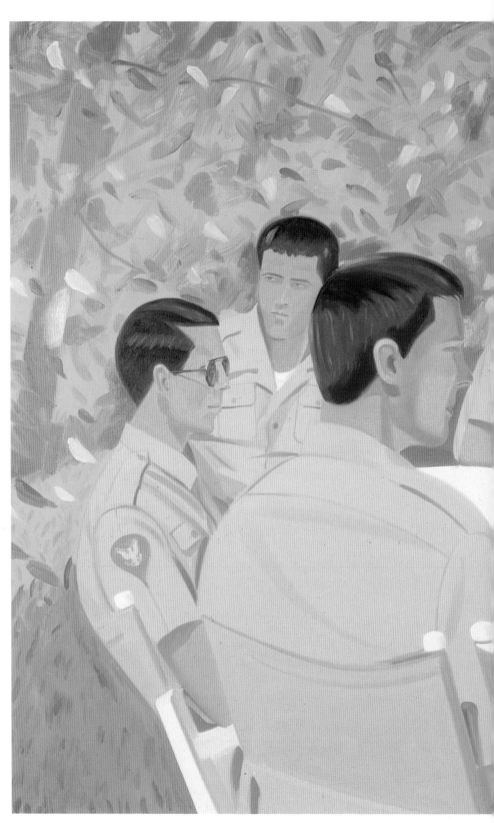

6. SIX SOLDIERS

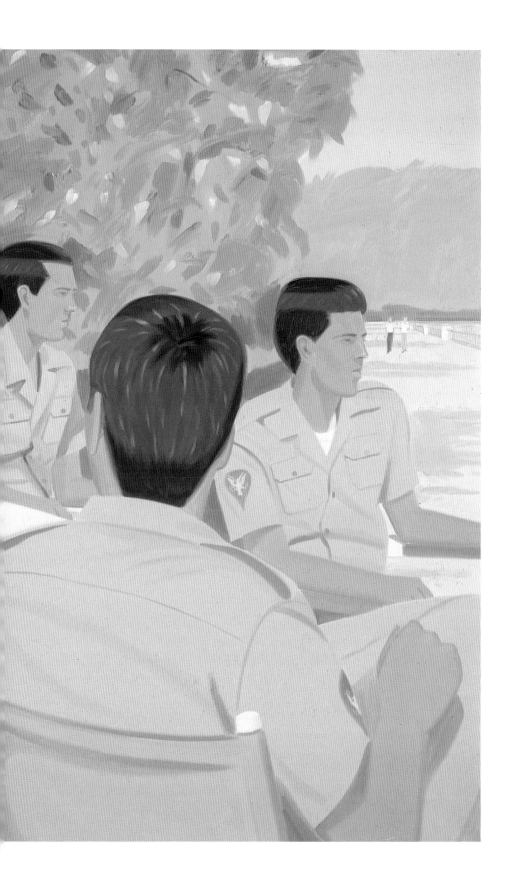

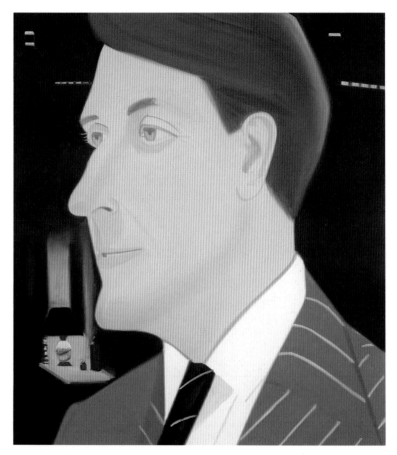

7. Jack Loring

motely at stake." Jennifer Bartlett says that she finds it pleasing to function in a utilitarian way and compares sitting for Katz to existing as a very good chair. "I don't think of being a model as just being a model," she says. "It's sort of like saying that the apples in Cézanne or the drapery are just apples or just drapery, as though there is another apple or another drape that would have been more suited to the task of transformation in some way." And for John Loring: "I'm a springboard for what he [Alex] wants to do. Jennifer says a chair, I say a springboard. Alex is going to leap off and do what he's going to do."

While Katz's subjects seem to assume that he is not obliged to reveal anything essential about their personalities—that the painter's goals may not come down to that sort of definition at all—at the same time such revelation is impossible to deny. Although his sitters are friends and acquaintances, Katz is hardly a contemporary version of the courtier, out to flatter: he has painted people failing to connect; he has painted them in the act of fiercely pulling away from one another; he has chronicled the end of relationships that have not yet officially ended. Quite often the light that Katz is so interested in falls beautifully on a world of alienation, sadness, and conflict. Try to talk to both members of a couple that Katz has painted, and one will often have to give you the phone number of the other. Tell Katz that the mismatched pairs make you nervous, and he will be surprised that impending breakups are apparent. His wife, Ada, one of his most frequently painted images, has appeared throughout the years in various incarnations. She, too, says that "he's put me in positions where—like other people—you become a character." Yet it is taken for granted that it is Katz's right to do what he wants. Paul Schupf, the private collector who owns much of Katz's work, considers it a foregone conclusion that in spite of having over fifty images of Ada, in paintings and drawings, none of them is really Ada. "I've got so many things of Ada—none of which is Ada—that I've learned to live with these images as just images." (Katz would be pleased to have his paintings thought of in just this way, though. A large painting by Katz hangs in Schupf's office that depicts Ada, seen up close, with a child on a walkway leading to the water behind her. It is clearly lovingly painted. Schupf says that Katz did not want him to loan the painting out for a recent show, and imitates Katz growling at him over the telephone, saying, "You like it just because it expresses sentiment.")

Well, here we are, in the decade when the delivery boy of the Whitman's Sampler has come back reincarnated as Keith Haring's cookie-cutter man carrying the big heart that symbolizes love, and no one wants to appear silly except on purpose. Some people have dismissed Katz's work as being nice in the pejorative, seeing it as tame, anonymous, too uncomplicated to be interesting, and the painter as curiously

unashamed to portray a world in which light still glistens as it did for Fairfield Porter and in which upper-middle-class people have nice days. But these people who have not taken the time to stare at the work are the ones who have passed through Katz's world naively; it is not the artist who has been skimming the surface. Yes, bright bouquets and little white sailboats can be found in the paintings, as can people in pinstripe suits—and nowhere, it seems, does anyone have a complexion problem—but these are stylizations and details that should not be dismissed as defining a pleasant world. Looked at in context, you have to wonder about their implications, and quite often come to the conclusion that the details function as subtle ironies. Katz uses ordinary things when they fit his purpose, not to reveal them for their own sakes. In fact, his world is not very defined by detail, not presented, even in these plentiful, materialistic times, as object-ridden. Usually there is enough detail to remind us of, or to sketch in, the natural world, but it does not really function to define that world. Katz's version of contemporary life has more to do with attitude than with things: the perspective from which he sees and paints his own house (plates 18, 19), which is an unexpected and disturbing one, suits his purposes more than an exact, detailed presentation of that particular place; the way couples interact—their touch, their gazes, their body language—is more important than the outfits they wear. The truth is that Katz, who has been criticized for presenting innocuously well-groomed people, wants them so attired not because it is his notion of conventional good style, but because he conceives of clothes as uniforms that do not deflect attention from the important things that need to be noticed. People miss the point when they talk about Katz painting surfaces; actually, he distrusts surfaces so much that he will not allow them to provide easy definitions of his subjects. When he tells Rackstraw Downes to "please not show up in your garage shirt" on the day he is to pose, it isn't a matter of what Katz (usually found, himself, in jeans and a shirt) considers decorum, but a call for surface anonymity. Painter and former art critic John Loring understands this well: "Alex told me he wanted me to wear my suit from work [plate 7]. Of course, that is not the way, living in SoHo, people think of me dressing. I think that was one of the things that fascinated Alex, having known me for years as a painter and printmaker in the loft across the street and then suddenly seeing me metamorphose into a Senior Executive and Vice President....[Tiffany's] is kind of an uptown loft, and it's a very different life, and you look different when you do these things, too. Everybody dresses for the role they play in costumes and with props. So Alex wanted a costume—the role that was being played at the time. Which is a great deal of Alex's painting: to include the props and costumes and the roles everybody's playing, in the context that they choose to put themselves into."

26

Katz's fairness as a social chronicler is that, beyond a certain point of selection, he does not orchestrate what he presents. While trying to insure that distractions that provide easy answers are omitted, he does not want to stack the deck with what he personally thinks defines and replaces details, *objets*, and props. Naturally, when Rudy Burckhardt stands with his back to the water in Maine (plate 5), a few sailboats move behind him, and it is up to us to see the contradiction they pose—to be all the more moved by Burckhardt's sad expression because we are reminded of the world of fun and freedom on a beautiful day. Gathered at a table, the men in SIX SOLDIERS (plate 6) are united physically but are distant from each other because their attention is variously directed, and it is up to us to notice the small, vague figures of a couple in the background who will at some point pass by, free in a way the men are not. Sometimes, too, we are cued to Katz's perceptions by what might seem to be his perplexing titles—titles that we would certainly not think of as inevitable, considering the canvases (UP IN THE BLEACHERS shows no bleachers; LINCOLNVILLE ALLEGORY provides us with no clear story, let alone allegory).

While it would be overstatement to present Katz as a master of evasiveness, it does seem important to note that he is interested in the ways in which people reveal themselves or try to evade doing so. He does not see their self-concepts as irrelevant. Without orchestrating the moment, he nevertheless provides them with a forum and, in painting them, gives them something as well as what he gives to a larger audience: the benefit—or betrayal—of time, ostensibly stopped. Katz is a stylist, but he is a stylist who believes in paring down. And he is painting when his audience has been conditioned to take for granted that intensity and importance are conveyed in close-up. The zoom lens has made literal the way in which we move in on something. Whereas our ancestors pushed their pince-nez closer to their eyes, we rush in with a camera lens capable of transforming the face in the distance into a composite of pores. We are used to the large screen, and to comic-strip cropping, which provides us with simplified close-ups of faces too large for the frame and too unimportant to detail anyway.

No one would argue that photography has not had a profound influence on painting. Yet in spite of the ways that Katz's portraits may be seen as analogous to the way certain photographers take a picture, when Katz comes in close it is not to reveal detail. Instead, his method, which seems so contemporary, actually forces us to back off, to stare, to try to figure something out that has not been interpreted for us in spite of the way the artist has selected the subject and composed the painting. Subtly, Katz is asking us what we believe in.

It would seem strange if a social chronicler such as Walker Evans had not doc-

umented both people and places. It would seem arbitrary if he had made the background—the specifics of poverty—unnecessary. Could we really know his people, whose lives were quite clearly reactions to their circumstances, without knowing the world they inhabited? On the other hand, W. Eugene Smith's famous image of a woman clasping a dying child almost demands that we see truth and symbolism at the same time: it refers to the Pietà; it is referential at the same time it is personal.

In his method, however, Katz is more akin to the recent work of Richard Avedon than he is to Evans. When Avedon recently did a series of portraits entitled "In the American West" and posed the people against a solid white backdrop instead of showing the land, the texture and context in which these subjects lived, some people said that in doing this, Avedon was being unnecessarily mannered. Although Katz's portraits are not as severe as Avedon's, with their nonexistent backgrounds, many of them provide us with no expected visual context, either. It is quite possible that Katz finds this a fair approach, though, instead of a stylized, artificial one. Consider the new trend toward motif rooms in discos. Allowed to create our own stately pleasure dome, it appears that we are comfortable moving from one context to another; we enjoy being different actors depending on what production we appear in, and where it is staged. This is an era of mix and mismatch, and context has often become something we create so that we can exist in it chameleonlike, anyway. Why should artists believe that the world defines us when we have made a joke of that notion ourselves?

Taken one after another, Katz's portraits can be seen as a contemporary document. Study them closely, and it is apparent that his subjects have moved into positions like dancers, or like lovers in the movies—but what we do not know is where they are going. Sometimes, as with Up in the Bleachers (plate 14), it is even irrelevant where they are. And when Katz turns his attention to the natural world, omitting figures, he lets that, too, take on a meaning of its own. The Yellow House (plate 18) must be studied as what it is; the branch of a tree must be seen as that, and not as it attaches to a tree trunk that is rooted in the earth. There is an authority about the painter saying: Look at something—really look—and know that it is this way because it is what *it* is, not because of context or because it is part of a whole. (Katz is hardly unique in this, of course. In much current literature and in film, the subject of looking is itself addressed. *Blow-Up* transcended being a period piece because it functions as a paradigm of the artistic process. Affiliated with the photographer in the film, we come to realize that we are also in the position of shooting randomly, or by habit or instinct, until something catches our eye, some detail we need to look at closely.) Katz's method of obliterating or barely presenting backgrounds forces us to look at things nakedly, forthrightly. It seems to be a pattern, too, that in spite of his proximity to his subjects,

28

their expressions do not acknowledge the painter or the process. They look, in RUDY or in JACK LORING, to whatever else they see—not interested in making contact, or stopped by the painter from this possibility. It might be a good guess that instead of just portraying people, Katz creates, in exaggerations and with a kind of pantomime, human representatives that are stand-ins for attitude. More analogous to objects than to psychological studies in the way they are presented, they often appear as objectified as a statue, yet they are no less capable of registering or conveying real emotion than the child in Smith's photograph or the faces of the Pietà.

In an essay about why she writes fiction, Joan Didion discusses the motivating force behind *Play It As It Lays* by speaking of translating pictures in her mind into language. "I had only two pictures in my mind, more about which later, and a technical intention, which was to write a novel so elliptical and so fast that it would be over before you noticed it, a novel so fast that it would scarcely exist on the page at all. About the pictures: the first was of white space. Empty space. This was clearly the picture that dictated the narrative intention of the book—a book in which anything that happened would happen off the page, a 'white' book to which the reader would have to bring his or her own bad dreams…." So, too, with Katz's portraits, we have to be conscious of the space around the subjects, know the person by intuiting what we will about emptiness. Surely if she convincingly creates an identifiable state of mind for her character, Didion cues and conditions us so that we will not merely read about Maria Wyeth and free associate. If we see the subjects of Katz's portraits clearly enough, we can imagine generally where they look and why, and know them to the extent that we do not misread them. In SIX SOLDIERS, it is one man's preoccupation with something far to the side of the action that is the issue, not the exact object of that preoccupation; in UP IN THE BLEACHERS, it is a group that functions as a non-group—people with no direct focus, no way of interacting—that is the painter's vision, not a group of people shuffled together awaiting the viewer's projections. What the *dynamic* is is the operative force; they are mysterious neither in dress nor in the way they relate (the mystery is why they are this way, not in their lack of connection).

We know there are borders—limitations—to what we experience. Most any artist considers the question of why he or she cropped the picture where it is cropped or ended the novel where it ended to be a difficult, if not impossible, question to answer. Yet at the same time, the question is a fair one. Why shouldn't we see Ada's shoes in ADA RECLINING? In ROGER AND SOPHIE, why don't we see Roger as well as the dog full-face? The real question is: who dares to determine advantage, and what does that consist of? If we intuit that we know all we need to know of Roger, then the partial view of him seems appropriate and pleasing, in that it allows our knowledge and imag-

ination to fill in and we can feel that we are part of the process. It is only when we cannot trust what we see and therefore suspect some pertinent information has been withheld or manipulated that we become anxious. Look at Jack (John) Loring (plate 7). He has all the trappings of a conventional businessman; from the striped suit to the neatly cut (and Katz-styled) hair. He has an expression that, while not happy or sad, is not neutral, either. He is seen in profile, rather relaxed, with slightly parted lips, his attention on whatever he is looking at. But what are we looking at? A subject come in on close enough to reveal his flaws if the painter so wished; a man whose clothes give us information about the context in which he lives, while at the same time the painter cuts us off from the particulars of that life. The parts of the body that might reveal action do not exist as part of the painting: John cannot tense his hands or lean from the waist. In fact, he is a bust, the horizontal line of his jacket that ends the painting rising high, so that we notice the knotted tie, the tightly fitting shirt collar. For all we know, in the office next to his, Hiroshi might be standing. It is the same night sky. For all the closeness the painter has with John, we do not know much of anything except that this appears to be a conventional man, seen close up, in profile, thinking something. He has been defined for us, but not described or clearly delineated. While it appears that we have a direct representation of someone understandable, we do not know anything in particular about him. We have no way to guess—no details that clearly reveal or betray. His largeness and his plainness could also be the painter's tacit admission of an obstacle. For all the close perspective, for all the simplicity of the presentation, the larger issue is that John may mesmerize us, but he is still unknowable. We might come away from the painting thinking that his nose was a little long, that we could not quite read his expression, but since these are not issues important enough to fixate on, we would more likely say: "Oh yes—that was John," and if asked for more detail, we could say that he was seen at night and that he was looking somewhere. At something.

This is the sort of talk that makes us stop ourselves cold. We know that we should give details. That stories and descriptions should be vivid. And while it seems we had a tremendous advantage—that we were physically close to John and that nothing confused or confounded us—it is difficult to sound convincing about who he was or what he was feeling or why he was there at all. It is as though David Hemmings in *Blow-Up* aimed his telescopic lens not at the people in the park, but up at the sky. Because art exists as something that presumes to define and sometimes even explain things, it is rare that a painter, or any artist, will call that basic precept into question—the idea of knowing, automatically, by seeing closely and without major contradiction, our sensibility allied with that of the perceiver. In portraying John in this way, Katz

has all but made him interchangeable in our emotional lives with a Doric column seen from a near perspective, with enough detail to allow us to say that yes, it is Doric as opposed to Ionic. We must also say that there is some mystery that has not been (does Katz think cannot be?) interpreted. With John, no ostensible problem (in the manner of Robert Longo or Eric Fischl) has been posed, and no answer has been given, though this is hardly a lesson in Katz's passivity. It is instead a cue to his sensibility: that the process of our knowing and naming may be suspect.

There is a stillness about Katz's work that is difficult to articulate. Looking at one of his portraits is like looking at actors standing still onstage for a few seconds as the curtain rises. If a play begins this way, it is because the frozen moment allows the audience to direct its attention and to get its bearings before the action starts. With Katz's paintings, the narrative action stays frozen. As with David Hockney's and Andy Warhol's portraits, what we know will have to be figured out by staring at the image itself. A play will unfold for us. A Robert Longo triptych in which we see a collapsed highway and a kiss does, in effect, unfold, as we deduce that there is some story line—but what Katz presents us with is an assessment he has arrived at that will not become any other ongoing reality. We are looking, most often, at a large, still image. Very little energy is captured: more often, people are seated at tables or in a room with a window behind them. They do not seem awkward, but neither do they seem entirely at ease. It might be that Katz senses an inherent grace in the rather formal ways people come together to pose, and therefore he does not think it unfair to drop out the larger world and let people sit or stand or relate to one another frankly and calmly. What we do not know from studying the paintings is anything about how these people really move through the world. Even with a painting meant to show people in motion, such as SUMMER TRIPTYCH (plate 16), we are not really under the illusion that Katz sprang up and captured people out on a walk. The painting is too stylized for that. It is more like a version of walking than the act of walking truly depicted. Katz is discreet, almost: no Robert Longo interrupting motion to freeze the figure with his ray gun. "There's a theatrical quality to his work," Jennifer Bartlett says, "almost as if there's a proscenium where for a moment people are together. I think there's a great sense of theater. It's not like people caught in their bath or brushing their teeth…they're very dramatic."

Beyond his technical concerns, Katz is interested in what happens on at least two other important levels: the formal (with Katz, this is synonymous with dramatic) way people appear to come together, and what they reveal unintentionally. If Katz operated by concept alone, he would not need models; he could merely set up his easel and imagine human forms. But it is not his will that he wants the models to bend to.

They are at once actors and real people whose inner lives shine through no matter what their positioning. To say that Katz likes drama is not to say that he likes artifice or pretense. Whatever the people are doing seems reasonable at the same time that it may be exaggerated. If it does not invite us in, neither does it put us at an impossible distance. Essentially, we know these people: most are attractive but not beautiful, with conventional clothes, combed hair, and with some dynamic worked out between them if they are couples, or else between the individual and the painter. What is interesting is that there is no way we can imagine strolling into their worlds. The couples are at once private and complete, unapproachable. Time and again Katz has painted public performances of a private reality. We see it with RED AND LIZZIE (plate 22) and BATH-ERS (plate 21). Though it may seem risky to other painters, Katz does not mind coming in at the point when people have already arrived at some conclusion about themselves. Though the relationships may or may not endure, they are as the people would want them understood during the moment of the painting. And always, Katz shows the people in stillness—they are allowed to think things out, to formally present the image they want of themselves. Catching people in the bath or brushing their teeth is not inherently good or bad. What it does do, though, is remind the viewer that the artist is an intruder. And it is Katz's posture to say: Get together and stop when it's right; I'll suspend judgment and record that. We are given the impression that the artist who is intruding (as of course he is, by his presence) is not really interpreting at all: these people have their own dramas, and Katz merely acknowledges that they are staging them. That the people are not confused does not mean that the viewer should not feel confusion, though. That they have arrived at a decision about themselves does not mean that we should agree with what they see—or that we might not see something else. Katz is obviously orchestrating something that is coherent aesthetically to him when he joins canvases together as he does in SUMMER TRIPTYCH or with the five-part series PAS DE DEUX, of which RED AND LIZZIE is a part. But the individual paintings of couples—especially when considered cumulatively—insist on certain constants. Foremost among these is that when two people are together, they seem to form a whole that is larger than the sum of the parts. We do not see worlds we might comfortably enter, because the involvement is so total, the moments so intense. It is as if we are being told: Look, but do not touch. Directly related to this is the fact that for all their closeness, for all the proximity of bodies and faces and hands on arms and shoulders, Katz paints the people's hands in such a way that they seem to be laid down rather than truly curving the way a hand, in life, would grab or link itself with another. He is showing a semblance of touching, in the way he paints, just as the people are posturing a relationship as they enact their drama. And the couples' attention divides,

almost inevitably. One has more energy than the other. One sees something the other, lost in the privacy of his or her world, cannot see. Paradoxically, though they are together in point of fact, they are not united in the way they might think, or in the way we might wish. And then there is the fascinating question of what the painter thinks—what it means to him that with so few cues to his subjects, they enact, time and again, situations with quite disturbing implications.

Paul Schupf has observed that "Nietzsche said that in the end he preferred Debussy to Wagner because 'the music did not sweat'. Alex's work does not 'sweat.'" It is true that we could not look at Katz's paintings and sense that angst determined the creative process. And a certain placidity would no doubt be appropriate to convey that the painter was allied with his subjects' moments of composure. Katz is undeniably more interested in coherence than in chaos, but what he chronicles may be a strain or alienation that his subjects pay a price for, and what the painter does, himself, is not easy. What is communicated from the various images of sunny days and close embraces can still be fairly interpreted as complex, contradictory, and sad or frightening. Katz presents the images coolly, and his interest is in formality: in people who are not harried or passionate or in a state of chaos. But one need not enact extremes to be so dramatic that one is convincing. While we are used to action being interrupted, Katz's subjects have not been involved in enacting exhausting routines to begin with. They are depicted at times when they *should* be relaxed (RUDY; SIX SOLDIERS; and TRACY, who sits not out of exhaustion, but because she has found a place and a reason to sit). There is something automatically compelling about interrupting someone else's expenditure of energy, but Katz operates more out of the tradition of the old-fashioned portrait painter, who has all the time in the world to paint people who have all the time in the world to give him. A strange notion in these harried times—and certainly more artificial than it was in the nineteenth century. But in spite of what might appear to be effortless technique applied to inherently comprehensible subject matter, Katz has been a rather daring painter all along. Working out of a naturalistic tradition, painting some of the same things Fairfield Porter might have painted, Katz has decided to pose us with the problem of a vision in which he is interested in what is simple, but to present that simplicity in an exaggerated way. He has decided that it is perfectly fair and appropriate—especially because his subjects will it—to let in artifice. We might look at his portraits and think that we are looking at a new-age Easter Island. He presents us with large things that are deceptively simple, believing that the remarkable is to be found within the ordinary. And he believes that if he can rivet our attention, we might look long enough to decipher this. "I don't think Alex has ever tried to make it easy on himself," Paul Schupf says. "On the contrary, he's made it

even harder on himself by making the tough shot look easy…Alex has never gone for the apparently tough gesture—the grandstand catch. Alex is the kind of guy who, even if he was seven feet tall, wouldn't slam it, he'd play it off the backboard like we did when we were kids. He'd just do it the elegant, simple way. That's just the way Alex does things; it's the way he dresses, it's the way he talks….Everything Alex does is kind of graceful, very spare…he doesn't carry any luggage around in his life."

In not taking the trendy, easy shot of seeming to capture motion, and in daring to paint people and places in such a way that we must stare to understand them, Katz has provided himself, as well as the viewer, with an interesting challenge: to look closely and fairly, and to assume that what is inherent will become apparent, so that we will find aspects of ourselves in what we observe on his canvases. Jennifer Bartlett explains how Katz conceives of his paintings: "There's the subject matter—which would be Eric and I [in OUR EYES HAVE MET, plate 26] looking into each other's eyes. Then there's the content of the picture, which is how the picture looks and all the things you receive from that, which are less easy to receive, which are less easy to explain, which are the important part of the picture."

The content of Katz's paintings is seemingly simple, but actually quite complex; what seems to be suspended judgment by the painter is actually subtly interpretive. Though the images do not launch themselves at us, we may still be as surprised, in the end, as if they did. Given that nothing is easy, Katz is painting as simply and as gracefully as he can, and he is asking us to see where grace—or the lack of it—resides in his subject matter. In the best of the paintings, what begins as mimesis finally radiates as metaphor.

Ada

Painters paint the objects of their fascination, knowing, as they do it, that mysteries can rarely be pinned down. When Alfred Stieglitz photographed Georgia O'Keeffe, objectivity was not one of his criteria. He tried to get at his lover the same way poets try to address the objects of their affection through metonymy and metaphor. The photographs of O'Keeffe are not just about an individual, but about her interaction with the artist (implied, not stated). Because his sensibility directed his selection, they are also a definition of Stieglitz as well.

If there is a common denominator to Katz's presentations of his wife, Ada, it may be that the paintings do not often catch her actually doing something. Usually she is lying down, or sitting and resting, or only her face is painted, so that we know little about the moment or about the larger context in which she lives. Katz has spent years contemplating Ada contemplating. She is, for him, an image of repose—whether her head breaks the surface of the water wearing a green bathing cap or she stares out from behind a bouquet. She is solidly and surely there, and she is rarely provided with a real-world context. An exception to this is LINCOLNVILLE ALLEGORY (plate 9), where Ada sits in the foreground, a woman at a picnic table outside a beach restaurant on a summer day. The presumption is that she has been caught—she is relaxed, but concentrating on something—and the fact that she has some attitude and some affect is what predominates, rather than specifics about who she is or what in particular she

is thinking. There is no reason to connect her thoughts—or even to connect Ada—with what is going on. In the easily recognizable context we are given, there are no contradictions, there is nothing to distract us from looking at her. Everything is peaceful. Time really seems to have stopped. Ada's hand seems to blend into her face. The three smaller figures to the left are gazing to the side, staring ahead, waiting at the restaurant window. These are not people who could easily be cued to freeze their action on a movie set. This, probably, really is an off-moment. And how peculiar that in a place we usually associate with a fair amount of activity, here are people separate from one another and lost in thought. If we take this as "real life," these people are unreasonably calm. What the painter insists on is that there is a peace that unifies them, a calm that transcends the continuum of time. The clouds that streak angularly across the sky, like fuzzily painted loaves of French bread, seem to take on a life of their own; above the people outside the lobster shack is movement that suggests a larger, stranger world.

In spite of the title, it is difficult to imagine that Ada and the children stand for anything beyond what we see—that, in effect, they are in any way conduits. Visually, this might well be an archetypal scene of people on a summer day; we know them in general, but not specifically, and no clear information is provided by the painter. Had he wanted to editorialize, he could have: the painter who undercuts any notion of verisimilitude by painting such clouds could interpret differently than he has. If in fact this is an allegory, it is a subjective, covert allegory that is impossible to decipher. But if the figures have been caught imagining their own stories and allegories, then what we are presented with is a painting about people's private worlds, and the realities that mitigate their lack of connection with each other or with something larger.

LINCOLNVILLE ALLEGORY is reminiscent of many other group scenes Katz has painted. Wherever Katz's people are, they are lost in their own thoughts, carried to their resting place, stopped where he has chosen to stop them. What the painter has done is uncompromising: it is the equivalent of a record stuck in a groove. If there is to be any progress—any story of the painting—we have to superimpose it. Yet the temptation is to go in the other direction and fixate. What is Ada thinking? What allegory might this be, and what might she be a symbol of? What is the truth of a summer day? Out of this strange stillness, we might come to some epiphany.

When we look at Stieglitz's photographs of O'Keeffe, we feel that however subjective he is being, he is still trying to present someone and to have the viewer feel something as close as possible to his own emotion. He is not, like Emmet Gowin, when he photographs his wife, Edith, wishing to have something enacted that is obviously

symbolic. The Edith we see is often photographed acknowledging the artist's presence: in photograph after photograph, we see not only her level eyes with their even stare, but Edith mugging for the camera, sticking out her tongue. In painting after painting of Katz's, we see an Ada who does not acknowledge and connect. For all the times that Katz has painted Ada, he has allowed her a strange sense of privacy, after all. In ADA AND FLOWERS (plate 8), she looks like a blind person who knows how to open her eyes to approximate the way sighted people look at something. Yet she looks at nothing: not to the distance, and not myopically to the flowers. Though she is positioned in different places, she is not defined by them. It is as though Ada precedes these things, these moments. We are shown over and over that externals are extraneous, and that her demeanor is a constant.

There is a sense of wit in the presentation of Ada in PARROT JUNGLE (plate 10). The shirt she wears refers to another world, whereas she is, at the moment painted, very much of the moment. When you consider the way she reclines on the Victorian sofa, her hair painted so that it appears that there is a confluence between hair and sofa, a link is forged between the rather silly, commercial world represented by PARROT JUNGLE and history. Her pose, too, is a model's pose—reminiscent, even, of Goya's Maja. Specific elements acknowledge and exist as a kind of comment on the times in which we live—certainly, these are not consistent times—and with tongue-in-cheek, Katz adds, as well, an homage and a sense of history by painting this particular pose. The traditional, old-world sofa is Ada's stage set, where she reclines, dressed in a silly souvenir sweatshirt no adult would wear unless she had a sense of humor. At the same time, though, its presence undercuts the seriousness of the Victorian furniture. The forties fabric she rests her head on is another textual incongruity. But again, in spite of the context in which we see her (and here we have information, as we did not in LINCOLNVILLE ALLEGORY, of how she sees herself), we know something *about* Ada, but we cannot say we know Ada. Her gaze is lovely, but the information we have to read into that only takes us far enough to say that this is a person in a particular moment, who is perhaps consciously parodying herself (or adult notions). The sofa may also be seen not as a historical artifice, but as existing now in a kind of limbo, not related to much of anything—a souvenir also. The yellow wall—a version of the tropics, imported—seems a little shocking, too. Only the painter's model's pose may be unintentional. We betray ourselves sometimes with formality, as well as with informality.

ADA RECLINING and VERTICAL EVENING (plates 11, 12) seem to come out of a different sensibility. Both seem very serious compared to PARROT JUNGLE. VERTICAL EVENING plays with our notions of the world. More likely, our tendency is to think of

the evening as horizontal (the sunset; the horizon line). That this is evening at all is clear only because of the narrow triangle of darkness outside the window (the eye is carried up and away to its tip; it is as though the bars of the window were ladder rungs, but at the top we have gone nowhere and must return to earth). More than the other images of Ada, this painting seems to be not only about Ada as a person, but about shape: the curves of her hair, the shape of the desk she sits at, the triangle formed behind it, where the curtain has moved away from the window. Katz has compressed and made the natural world a little surreal. The darkness is painted as though it rises spikelike, out of the desk itself. In contrast, Ada seems very human, and very real. We are seeing someone caught in a reverie, but what exactly is happening remains as enigmatic as the Mona Lisa would be, even if she undertook some activity. Ada's quiet composure seems, in painting after painting, to have an almost tactile quality. Clearly, she has an inner world, and if we need to engage with her, our expectations will never be met. In her stillness, she becomes objectified—an object of fascination, though, and not in any way dehumanized—and we study her stillness as part of the scene in the same way we would understand the fluidity of a piece of sculpture and see the world around it transformed by its inherent movement. The narrowness of the canvas is suggestive of a ray of light; it is possible to feel that we are facing Ada, but at the same time to have the sense that since so much emptiness stretches above her, we are also looking down at her from above.

In ADA RECLINING, we again have a frontal, as well as aerial, perspective. Sitting, standing, involved in activity, sleeping—we are consistently presented with Ada composed, lovely, and quite sensuous. Here, the curve of her lips, her glasses and her hair emphasize her humanness, in contrast to the rather harsh diamond-shaped pattern behind her. Triangles—one of Katz's favorite shapes to show the way light falls— are obvious on this canvas three-dimensionally, as the fabric rises to a mountain peak at Ada's shoulder. Triangles are visible again where the shading comes in from the right and the bottom. Another triangle is formed to the side of her throat. The triangles are patterns that, as they come to a point, make our eye move—direct our attention elsewhere as well (here, to the crazy fabric). While the fabric is chaotic, Ada is, by contrast, calm and deceptively simple. Stretched out, Ada seems an indisputable fact. But we notice, too, that she is not connected to the beach towel, and as she sleeps, her thoughts are unknowable. Where she is placed is always plausible, and what she is is always a mystery. She is, time and again, a person on whom light falls, a person whose face is so subtly shaded that it lacks the expected planes and takes on a symbolic, mask-like quality. This is Ada refined into untouchability, yet infinitely real: tactile, with her thick hair curving along the sofa back or pushed away from her face like a bonnet that

has been rearranged as she rests. There is a transcendent stillness about her—something we associate with divinity. Even in sleep, she radiates a peace that we want to approach; she is a person we might well want to touch and to connect with. No inner tension is portrayed, no awkwardness is caught. Katz reinforces for his audience that Ada is *this* Ada, and that part of his definition remains external: the way the light registers on her, the way it makes a little game on the fabric of her shirt. Her hairline is deliberately painted too perfectly—a painterly refinement that makes her appear sculpted. There is even a sense that things have been placed on Ada, instead of that she is one with them. The mouth itself might have been placed at the correct point on her face in ADA RECLINING; certainly her glasses might have been placed there, the hair laid around her. Everything seems to have lightly and perfectly settled—as if her own features were emblematic, and not an enactment, of an inner peace. She is not of any moment, and is presented as self-contained, looking inward rather than outward—a symbol, in short, of a pleasing attitude or state of mind. At the same time, she appears real because she is tactile, sensuous, and inviting. It is an amazing feat that Katz has painted both a woman and a symbol.

In James Joyce's short story "The Dead," the protagonist (who stops for a minute, amid the mounting chaos of a Christmas party, to stare at his wife) is described in this way: "There was a grace and mystery in her attitude as if she were a symbol of something. He asked himself what is a woman standing on the stairs in the shadow, listening to distant music, a symbol of. If he were a painter he would paint her in that attitude." It seems quite possible that Katz's approach to Ada is much like Gabriel Conroy's toward his wife: that she is so real that she is larger than life—and in being this, she functions as a symbol. What *exactly* she is a symbol of would be impossible to pin down. The mysterious quality of her inwardness is compounded in the multiple paintings of her, intensified cumulatively. She is recognizable, while at the same time our attempts to categorize—to believe in some ultimate, understandable definition of Ada—grow more vague the longer we know her. But Ada is not revealed to be an enigma or mystery just as a tease. It is logical to assume that to raise the question of what she is, what she embodies and suggests, is a statement in itself. He has painted her so many times that while she seems an undeniable focal point of his work, an artistic touchstone, at the same time her constant escape makes her ephemeral and metaphoric. There is something gratifying about a thing as intangible as loveliness—so gratifying that we do not really want it to be caught. In insisting that she is true to life—casually dressed, seen in ordinary environments, doing very ordinary things—we are reassured enough that we will not become impatient or frustrated because this woman does not make easy eye contact with us or provide us with gestures to interpret

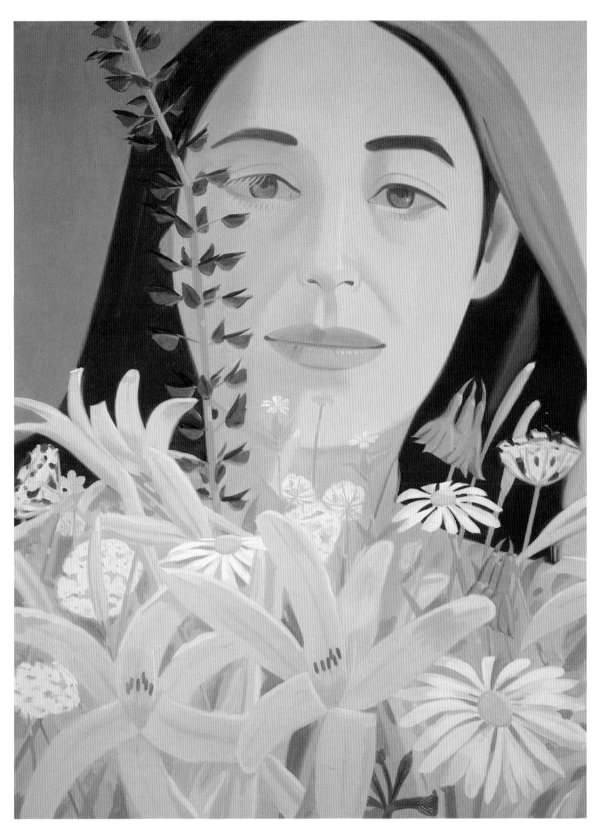

8. ADA AND FLOWERS

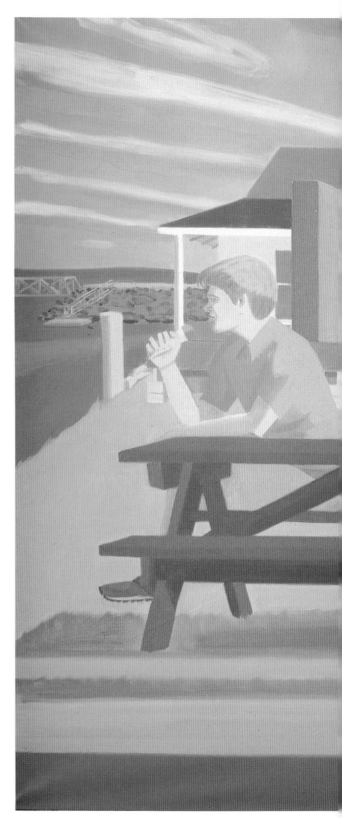

9. LINCOLNVILLE ALLEGORY

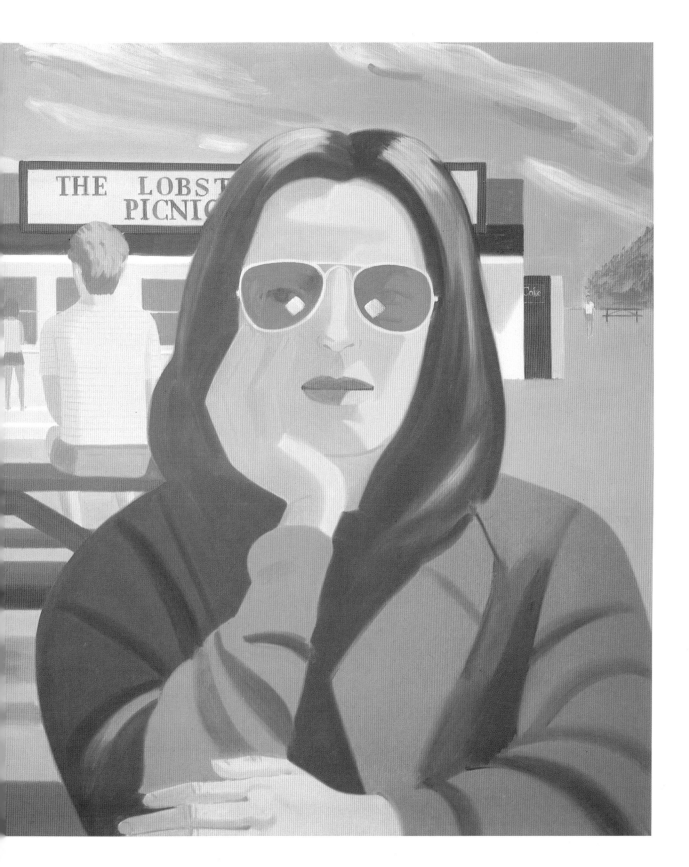

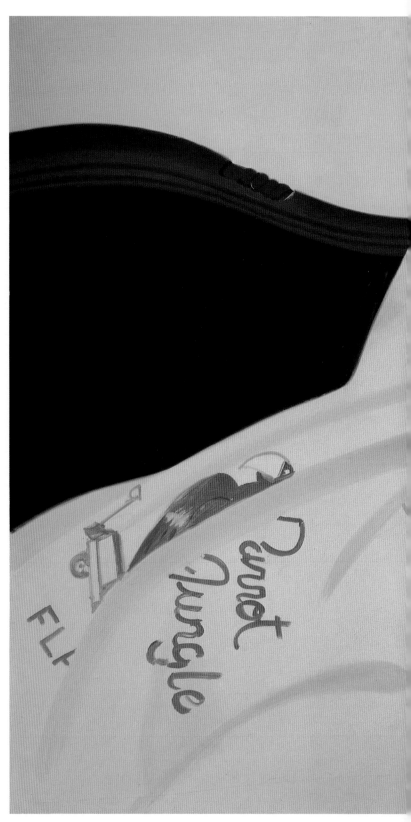

10. PARROT JUNGLE

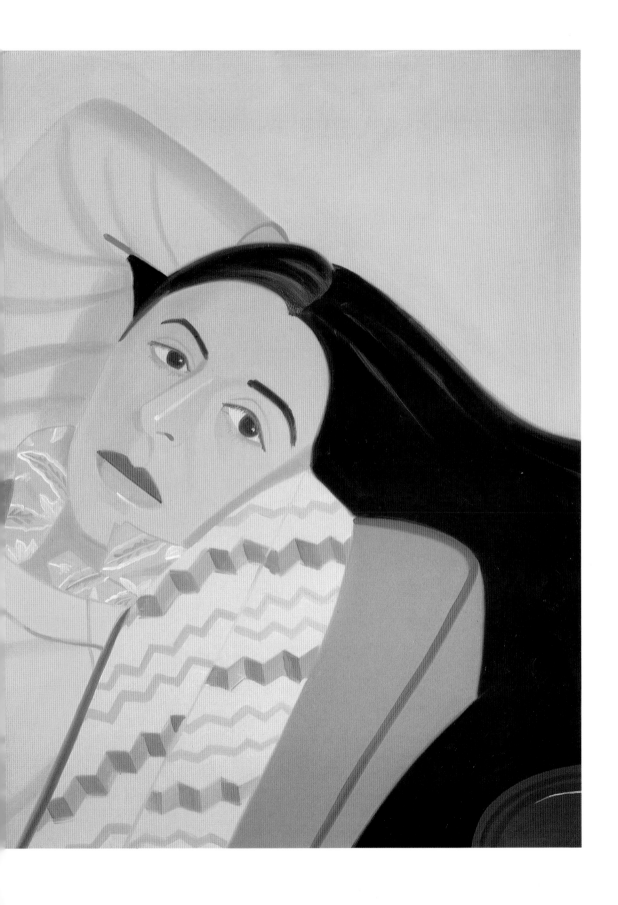

11. ADA RECLINING

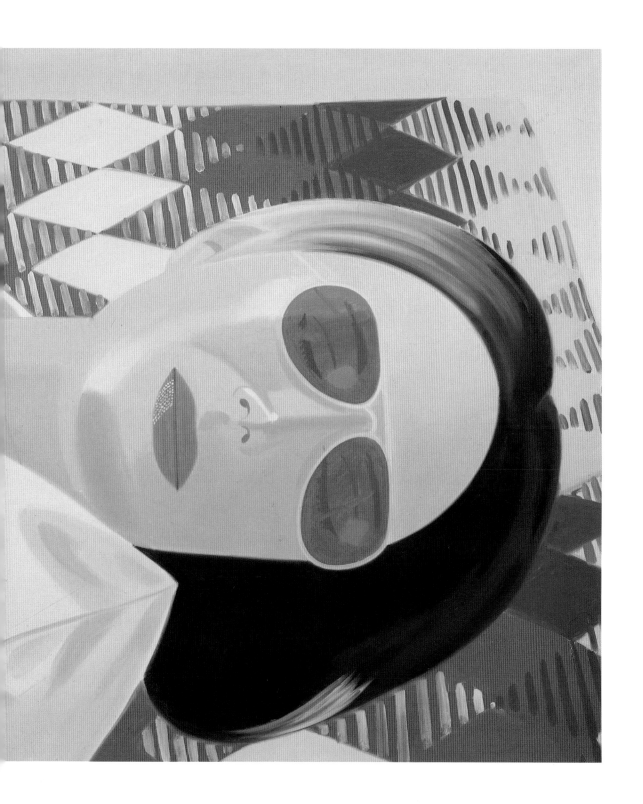

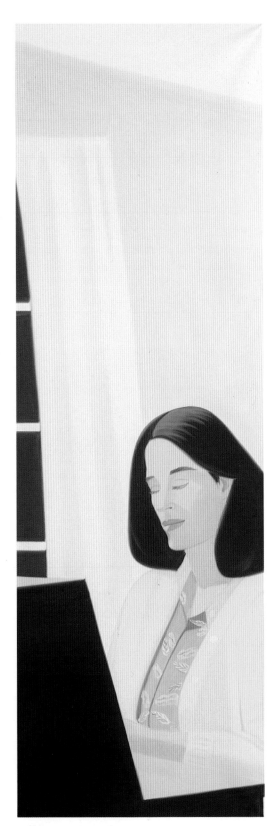

12. VERTICAL EVENING

or with many props that can convey a subtext of meaning. Because she seems instantly recognizable as ordinary, or usual—because she seems to be one of us—most of the audience will be seduced and begin to sense and appreciate the puzzle. In painting Ada, Katz is painting versions of peace and offering the possibility of contentment. His refinements, such as the too-perfect hairline, the smooth lips that catch a bit of light, the airbrushed look of her skin, are not romantic conceptions, but deceptive simplifications that seem to make clear what is actually quite complex. In reality, the more he objectifies her, the more complex she becomes. The surface is stranger than it first appears—an improvisation after all; when we thought we might be hearing a libretto, we have been given jazz—so that while we look at something concrete, we have to think of something abstract. In a way, Katz suggests something about how we look at the world through his way of looking at his wife: when seen apparently simply, the image can, of course, still hide the most complex things. In the best paintings of Ada, it seems that she transcends being a person that the painter knows and cares about and becomes an embodiment of an attitude that might be universal. Katz moves from the particular to the general—or, better stated, from the particular to the universal. Ada's depths are our depths as well. It is a good trick to make us think that we know her.

Narratives

U P IN THE BLEACHERS

The group in UP IN THE BLEACHERS (plate 14) might be considered the same way we watch Kabuki actors: the gestures, though small, are precise; there is much exaggeration, and we are presented with protracted or speeded-up time. If we were not provided with the title, we would not even have information about what these people were up to. What would be lost by calling the painting, instead, ON CLOUD NINE, except that if we do happen to know where these people are placed, the import may vary? In a potentially exciting social setting, these people seem very uninvolved. If Katz did not believe that the dynamic speaks for itself, surely he would not hesitate to particularize. But like Samuel Beckett who objected when *Endgame* was presented in Boston and staged in a subway—because he felt this setting particularized and made reductive his concept of the play—so, too, Katz wants little or no contemporary references to explain actions and relationships.

In UP IN THE BLEACHERS, Katz comes in close on eight people who display no affection for each other. Their similarities are apparent: with the exception of one woman's dress that looks a little like a costume, they are conservatively dressed and reacting conservatively. They share small physical details—or at least they are visually united by the way the painter curves their eyebrows and slightly exaggerates the size of their eyes. While they do not seem strained, neither do they appear comfortable.

Without any real incentive provided for us to create a group identity from this assemblage, we might instead consider them individually. In fact, we are almost required to, since they have their own concerns and their own levels of intensity. These people—with what one might assume is a common bond of social class and some shared world—might as well be jack-in-the-boxes who have popped up quite alone. Their attention is connected to whatever it happens to be riveted on, and of the eight, only one shows involvement with the painter. She alone reminds us that these people are this way *even though* they are being perceived. It is as if they are persisting in spite of the outside perceiver.

This painting raises a question about how we ordinarily penetrate the surface of people—especially people who seem to individually define the world by a collective philosophy that excludes emotional bonding. The absence of a real environment is interesting; players against a background, they have the potential to create a world, and yet they do not. (The men in SIX SOLDIERS have a reason to be where they are, and their reactions can be seen as a response to what they are and to what their situation is. TRACY ON THE RAFT AT 7:30 tells us something about the environment, and the environment tells us how to have a different perspective on Tracy.) Here we are at the mercy of the eight people to create an environment for us, yet they have chosen to be no more animate than the background.

These are the sort of people we are drawn to: a little mysterious; some kinetic energy we can almost feel; something there to discover. But we cannot use the two canvases the way we would look into a mirror. We have plausible people, often not so detailed that we are immediately drawn to them or not drawn to them, but they allow us only to study them—they do not meet our gaze. Most often, they are tranquil, but if they are not, we imagine in all but a few cases that they are imploding rather than exploding. That at the point at which they are presented to us, something has happened—and except for our assumptions about ordinary life, we do not know the details. We do not even know the larger story. What we do know is that on some level they tell a cautionary tale: we would not want to be the way the people are in UP IN THE BLEACHERS; we would not like to sit just the way the couple sits in THE THAI RESTAURANT on an evening out.

THE GRAY DRESS

In THE GRAY DRESS (plate 15), women are modeling gray dresses. Their raison d'être is simple to understand, and because it is clear that we are being shown something—our attention directed to some object that we are to consider in its various possibilities—it is possible to look at THE GRAY DRESS and be appeased by simple motives.

Psychological complexity is not even suggested by the surface of the painting. But people who show us nothing in particular and who do not connect with each other strike the viewer as frustratingly unrevelatory. What is obviously presented to us for judgment, three different gray dresses, makes us think about gray dresses and even about the women who model them, because we have a frame of reference for this: the models do not necessarily have to relate; surfaces rather than psychology are the modus operandi. It is when we journey into a real scene that our expectations are raised. In a photograph by Deborah Turbeville, we see not only fashion, but fashion as it integrates with and even defines a world. Katz is not interested solely in fashion any more than Turbeville, but rather in the attitude with which we display ourselves and create an atmosphere that defines some world. A mood is created by the presentation of the three gray dresses. Our frame of reference begins with the way we are used to seeing fashion presented: in a style that has become a convention, the models look at the camera (here, the painter), hands resting at their waists, and invite us to look at them a particular way, as poseurs. No such invitation is offered in Up in the Bleachers, where the people are not posturing, not focused by one concern (including being subjects of the same painting). In Up in the Bleachers, because there might be a unique way of presenting themselves, we feel shut out because the people are giving us nothing that we expect.

One looks to artists to select and define. The former is inevitable: the painter will choose a model or a subject. But the definition of the essential emotional components of the subject matter may be difficult for the painter, and audiences are often uncomfortable with ambiguity or with contradictions. Obviously, a true artist does not choose randomly, but it seems perfectly fair that the sorting out of complexities— once recorded—is as much the task of the audience as of the painter. In a case where the gray dress exists in his mind as gray dress*es,* we are offered a lineup of three possibilities that range from fashionably proper to slightly provocative—a dress that could be used in the late afternoon or at a cocktail party; a barer dress that would be more conventional at certain sorts of cocktail parties; and finally, a dress that would be as useful to wear when selecting vegetables in the store as standing around with a cocktail glass. Which one do we choose? Which woman do we relate to? We are always window-shopping; we are all actors to the extent that we consider potential images and identities for ourselves.

THE RYAN SISTERS

Although the scene we see here is nowhere near as ominous as the monolith of shadow that crowds in behind Tracy on the Raft at 7:30, the situation is similar in that de-

tails of the real world have been dropped out (plate 13). It is as if the world has fallen behind and below the Ryan sisters as they walk. It is a little as if the girls are cresting the roller coaster and walking into…and here the brushstrokes change. Let us assume for a minute that this is the way the world and the inhabitants really are. Would they be smiling and doing their paper-doll-cutout walk if they saw a putty-colored morass in front of them? Katz must have altered his brushstrokes in this manner on purpose, to allow the effect to work on us subconsciously. What we have is an impression, an abstraction, put there deliberately—something akin to the literary ellipsis. All that needs to be detailed in the painting has been put in, and our attention has been focused on the foursome. Yet the longer we look, the more we realize what the girls do not: that the unknown is just ahead of them—something vague and gray. It is a subtle comment by the painter that gives us knowledge that his subjects do not have. Deliberately, the warning has been given to the wrong audience. Though we have a naturalistic scene, the brushstrokes are not hazed in randomly, but rather operate to cue us about the unknown, the amorphous something that does indeed subsume summer days.

SUMMER TRIPTYCH

Though the three couples in SUMMER TRIPTYCH (plate 16) are individual portraits and cannot properly be considered as series shots, their separate narratives form a collective one that seems to stand as a whole. In this painting, instead of omitting the background, Katz works subtly, as he does in THE RYAN SISTERS or in TRACY ON THE RAFT AT 7:30. Just a bit of detailing suggests the leaves of what appears to be an impenetrably deep forest. The three couples are close enough to the darkness of the forest so that we think of them as people near the edge. The grass they stand in ends without tapering; the way the light green disappears into the green of darkness is sudden. It is almost as if Katz has taken a ruler and ended one world rather exactly while beginning the other right at its border. These are archetypal woods that symbolize the unknown (the painter does not put in details to particularize them), and the field through which the people walk is out in the light. The way the painter has painted the grass makes the people appear to be wading. Something suggests—with their buried feet—that their progress is not entirely effortless. Psychologically, these people's progress is impeded. We know something about them because they are having a day in the country, and because they have chosen certain postures—but while the way they walk or stand reminds us of movement, it is not genuine movement captured. The couple in the left panel could not actually take many steps in this position without stumbling; the couple in the middle has actually stopped, as their clasped hands indicate; the couple on the right suggests most movement, but the forward motion is more on the

53

woman's part than the man's. As is often the case with the couples Katz paints, the two people have different energy levels. In the panel on the right, the woman's half-interested, half-questioning look lets us know that she is leading them through the meadow in contrast with the statuesque couple on the left who are not moving. The painter has caught the couple on the right in the act of walking—they are not relaxed, the way the center couple is, and are not like the people on the left who have stopped and are only depicted in the posture of walking. It is as difficult to avoid making a judgment about the couples as it is to decide not to prefer one gray dress over another. The background does not neutralize them at all; rather, as the subjects play off against it (in fact, are oblivious to it), they seem all the more particular because there are no similar responses. Only their clothes form a link between them: they are casually dressed and relaxed—or trying to appear relaxed. They must know, as we do, that these are not woods in which a bear would likely appear, or where poison ivy grows. These are nearly monochromatic, conventional woods. They are woods that, because they are not used and because the people are not involved with the life inside them, are hardly real at all: a backdrop, necessarily archetypal, but a world that the strollers do not relate to. Except for their sunken feet—a situation they seem not to notice—the couples are not emotionally a part of nature at all. They have not ordered clothes from Banana Republic to establish some phony rapport, but their decision to look so tidy says a lot about the sure way they approach things. It must have been a foregone conclusion that they were not going to get dirty hiking through underbrush, because they have all worn ironed clothes, put on jewelry. They are conscious of the details by which they want to be defined, but seem oblivious to the inherent mystery and complexity of the woods. They might indeed wade easily through life, but something tells the viewer that such involvement with one another—that level of intensity—is transient. The cynic will notice that the couple on the left will eventually find forward movement impeded by this grasp and proximity; the middle couple is on the verge of movement, but has yet to begin, except to exert energy to pull away from each other. The painter has presented them in a moment that precedes movement we won't ever see. In the panel on the right, the eye contact is so intense—given that they really seem to be striding forward—that motion or intensity will soon have to lapse.

These are people who are responding to the artist's presence by ignoring it. One wonders what else they might be oblivious to—and whether, by placing them in the tall grass with the symbol of discovery behind them, Katz isn't nudging the viewer to question them. Katz gave the couples only the information that this was to be a painting about people touching. The way they have chosen to do this is informative. The common denominator between them—leaving aside their homogeneous good

looks—is that they are, as couples, all solipsistic. We cannot imagine the six of them meeting, let alone holding hands and walking forward like the Ryan sisters. It is a different dynamic—not a group dynamic, but a display of private dynamics, put side by side by the painter. Reading from left to right, there is no conclusion we can draw about the day, or about couples in general. We have moments to consider, but not a story. It should be suspected that, as with UP IN THE BLEACHERS, even if the people were moved onto one large canvas, there still would be no story. These are images of isolation as surely as the woods themselves stand for isolation. Katz records here—as he often does elsewhere—our separateness in spite of surface similarities. Images of lack of connection abound—and surfaces, like backgrounds, are only tenuous things.

Inanimate Portraits

THE TABLE

Although Alex Katz is most often associated with painting people, he has painted everything from the branch of a tree to a picnic table. While it is difficult to say that the picnic table seen here is remarkable in and of itself, it is nevertheless a perplexing painting (plate 17). If the painter can make us stare at it—if the table seems large and obvious and conventional but we are still drawn to it—we may have been given a clue about Katz's vision as well as a lesson in how to look and why.

As such, a picnic table is not very detailed. Detail is usually included so that something becomes more believable or unique in a way we may not have expected. Yet we would be foolish to look for particularization of a humble picnic table; we do not have the interest in detail the way we do when, say, we look at a bowl of fruit painted by Bonnard. This is just a picnic table—yet what associations we all have with it: it is a symbol of summer and all that the season connotes; it is a timeless thing, something that will not likely be refined, improved and recycled into something *au courant*. Its form is a composite of horizontals, an assemblage that is a little more complex when seen at this angle than straight on, an object that is revealed to us as potentially less simple than we probably first thought. It is a nice painting. Easy to look at. The table is composed of dark and light, a representation of what a picnic table *essentially* looks like, rather than a very defined, scarred, splintery table affected by the elements. We

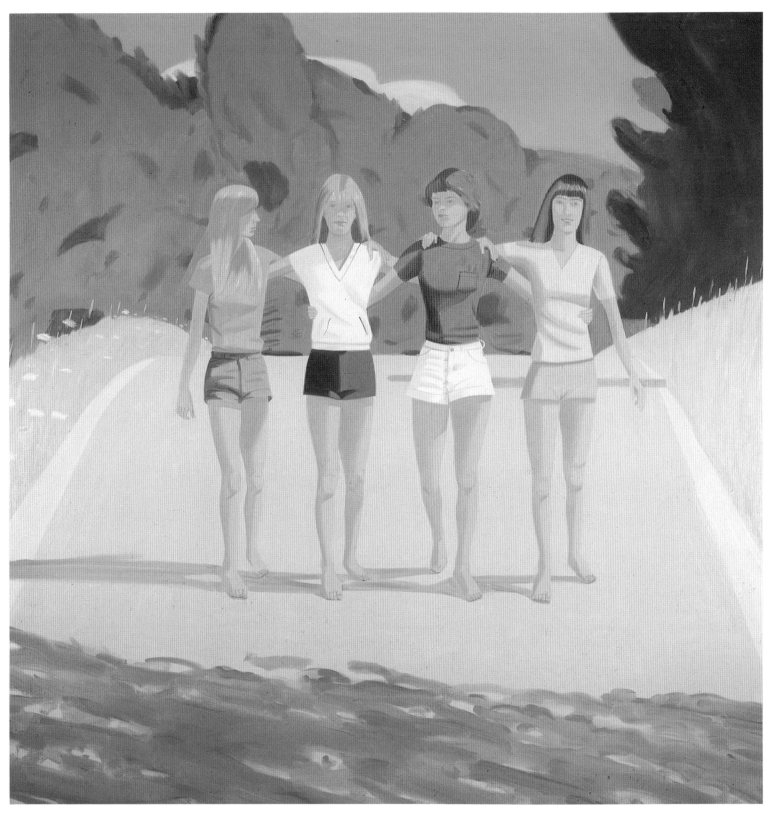

13. THE RYAN SISTERS

14. Up in the Bleachers

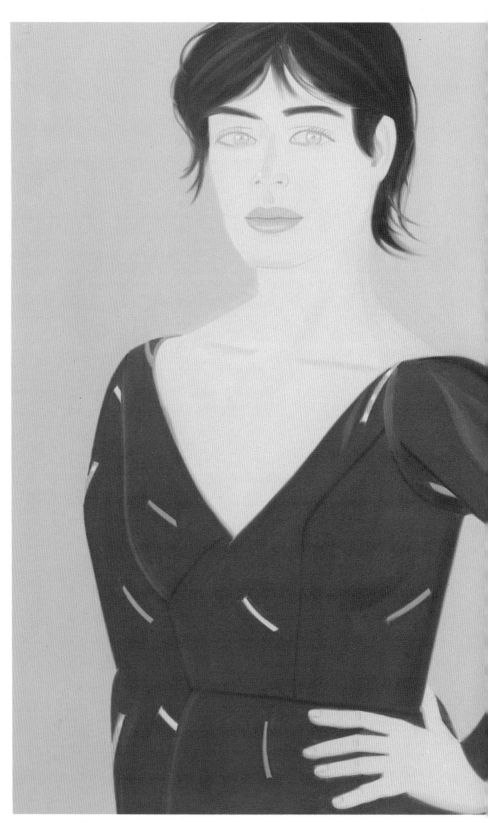

15. THE GRAY DRESS

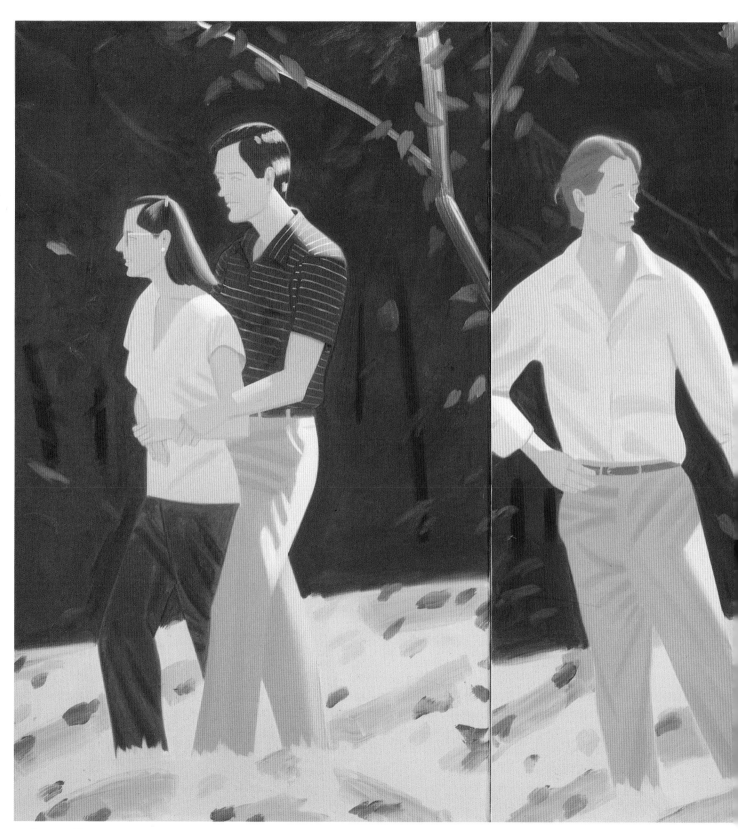

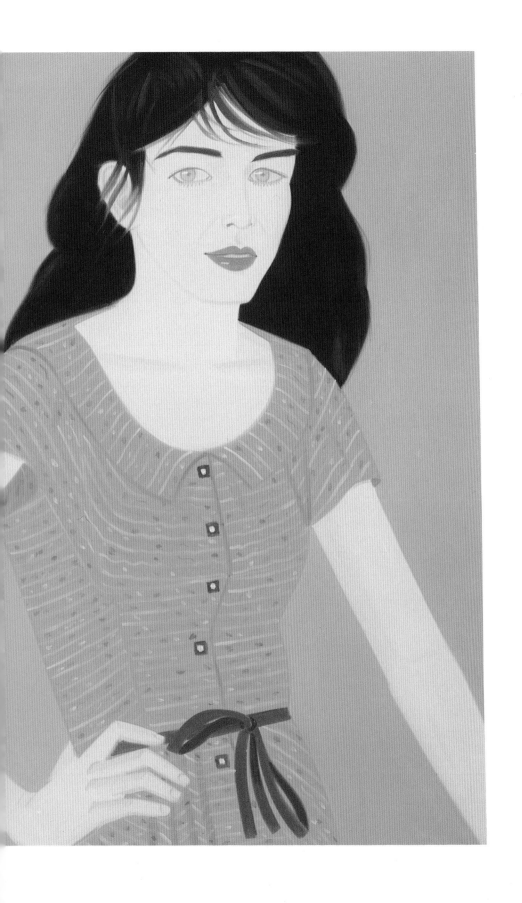

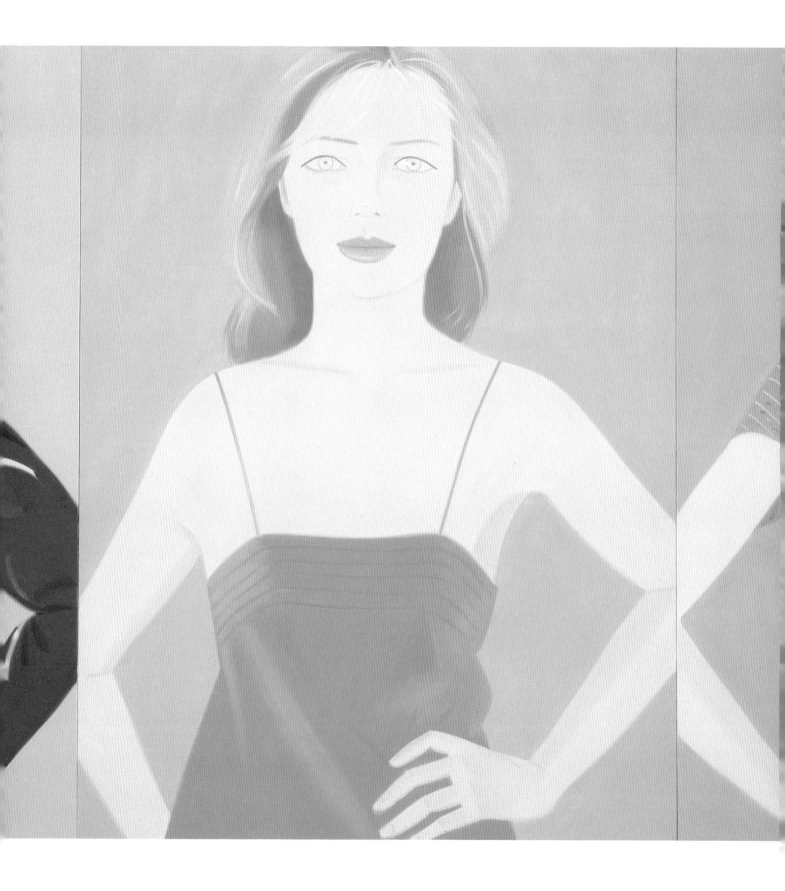

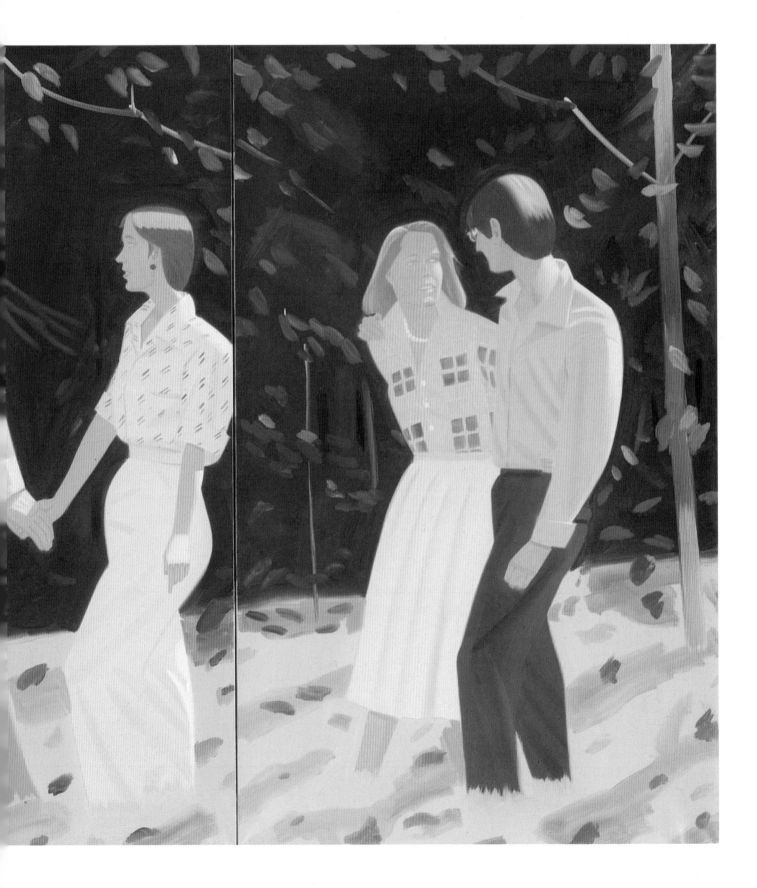

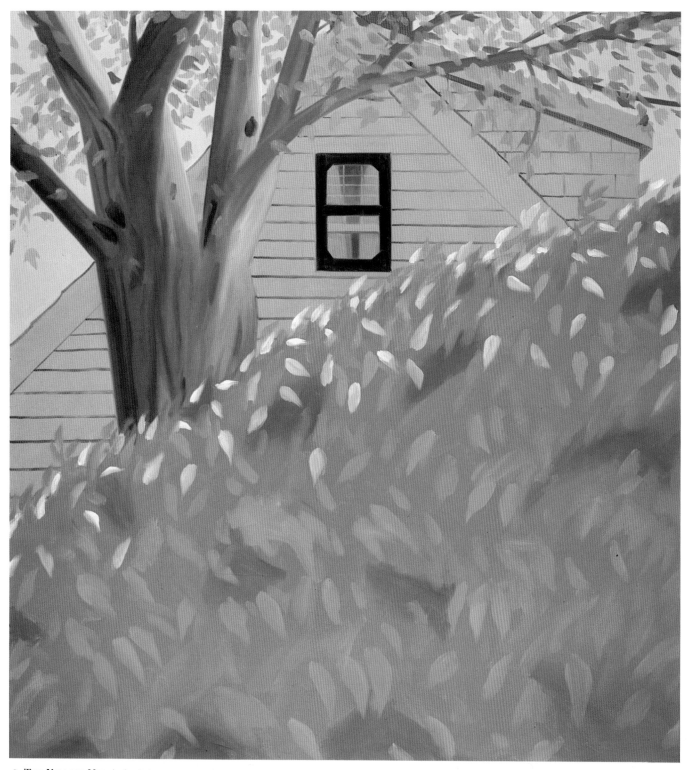

18. THE YELLOW HOUSE (1982)

17. THE TABLE

19. The Yellow House (1985)

associate this table with its utilitarian function, but since we do not see it functioning that way, it becomes mysterious, the way an empty movie house seems strange. What about this *thing,* this thing in its own right, instead of the way we usually think of it, defined by function? It forces us to admit that we rely on context—that context is linked in our minds with function—and that there is a provocativeness akin to nakedness when we must look at something in isolation. The table becomes a repository for our imaginings, a thing inherently useful, simple, and neutral. It is recognizable, though we may not have taken the time to stop and study it before. It also functions symbolically, and since we know what it represents, nothing needs to be done to interpret it. But we cannot be fooled into thinking that because it is inconspicuous, it is not important, any more than we can dismiss the people who appear in Katz's portraits as conventional and therefore understandable. There is no way to leave out the psychological intent of the portraits, or even of his portraits of inanimate objects. At the very least, we are told something about the artist's sensibility. This painting tells us what he finds worth presenting; that simple things have inherent beauty, even if it is a taken-for-granted beauty; and it suggests that things have an inherent quality. Though the table does not confound us or awaken us to some complexity we would never have imagined, having it presented this way still puzzles and attracts us. The picnic table is, if not of our dreams, of the painter's dreams, because his world is a dream, told to him and to us through symbols. This painting is a dream of color, of form, of the way light falls on the world. It also has enough openness, enough emptiness that is merely tinged with specificity that we at once believe in it, yet don't see it as so particular that we can only relate to it in some predetermined way. Given a symbol and a context, we may project a life upon it.

THE YELLOW HOUSE (1982)/THE YELLOW HOUSE (1985)

A more obvious example of undercutting is seen in the ostensibly simple YELLOW HOUSE of 1982 (plate 18). Here we question why the house has been approached from this angle. The lighter brushstrokes draw the eye upward. The little leaves seem to have a life of their own. They are like fish, swimming upward, into the light. The quantity of green seems to suggest a hugeness and solidity, but it is also more than a detailed version of a bush or cluster of bushes that grows outside a house. It makes us stop thinking vaguely of that which we call "nature" and think, instead, of its specifics. The brushstrokes suggest real depth (as does the shadowing, the layering of dark-on-dark in the sky behind Tracy), so that we have a real intensity of bushes, with some sort of near-chaos going on as the leaves become detailed, lighten, and move toward the surface. Movement is implied; changeability is implied. The house reflects on the bushes

(it is orderly, striated with horizontals; the bush is viewed with a kind of Impressionistic technique that actually—whether we back up or come close—presents randomness), and the bushes reflect on the house. Another world is right outside the traditional house that, viewed alone, connotes nothing. The tree bridges the gap. Painted a bit more realistically than the hedge, but not as realistically as the house, it reminds us that there is a middle ground.

What we see here is not the sort of picture a homeowner would take of his or her house. From this angle, we have to think of it as shape and, in context, of its texture. In a way, it almost has to compete with the reality of the high, omnipresent hedges. The inanimate object has the task of rising above the hedges, and of coexisting with the nearby large tree. Instead of being a detail to define and show off the house, the hedge/tree combination suggests a life that is rather complicated. The way the hedge has been painted reminds one of movement seen under a microscope. Though it might be consoling to peer, à la Edward Hopper, into the interior to understand the scene, this is not Katz's point. Proximity and what it means is what interests him. Subtle details that create a sense of strangeness reinforce his conclusion. Though we do not know the human scenario taking place in or around the house by an examination of the thing itself—as it is kept from us, and as it is changed by context—we are provided with a certain kind of information.

We cannot look at this canvas and think of the house as an archetypal, stereotypical house. Rather, it is part of a complex assemblage that we do not often think of in its complexity until an odd angle changes our perspective. The near-molecular movement in the greenery suggests a lack of stasis, yet a house is meant to be solid in the literal and metaphorical sense. The positioning here makes us question this as surely as Billy's proximity that is all distance from Anne (plate 23) makes us question what a relationship really is. The unexpected angle, the compactness of the house/tree/hedge configuration suggests a whole world that resists idealization.

Next, consider the same house in THE YELLOW HOUSE of 1985 (plate 19). Our attention moves to the bricks and shingles themselves. The house, in this context, has calmed down. Earlier we saw the top of the house (everything makes the eye travel upward in the other painting), and here we see its suggested depth and width. This is a more factual house, while the other was more metaphorical, more determined by context. This painting insists on its near-blandness because of the regular irregularity of the pattern. It exists as pattern.

Neither canvas is meant as a portrait of a house; rather, Katz has painted two different subjective views that have ways of working on the audience's subconscious to instill curiosity, doubt, a new way of seeing the world. Though the houses are

painted realistically, the context and angle in which they are placed and the cryptic point of view suggest that what we are being shown, instead of the ostensible subject, is an impression of a house—a house that may change our fixed ideas about what a house is. In one case we have a house that is in danger of being swallowed by a painterly hedge. No such complex response is elicited from the 1985 version, because this one is truly static. It is about harmony, balance, order, and finality. The primary colors, the sure strokes (but lack of overdetailing) don't direct our thoughts the way the earlier painting does. If we think about motion at all here, it is because we know that flowers and trees move in the breeze. This painting says: This is sufficient. Imagine it to be something else only if you need to. When faced with such a strong archetypal image, what exactly *do* we need? The subjective interpretation of the earlier canvas—even if it is ultimately disquieting?

Couples

Exceptions are always attention-getting: tall, striking women with inconspicuous men; handsome men with homely women. We look and know that we are not *supposed* to look. After all, physical beauty is not an acceptable basis for a value judgment. And yet—with couples, as with the rest of the world—our eye often tries to create harmony. Unharmonious elements may be interesting, complicating our perceptions in a way that implies a challenge to our intuitive sense of the matched, paired, well integrated. This aesthetic balancing act affects everything from clothes selection to the pairing of political candidates to our avoidance of putting three green vegetables on the table at the same time.

When we look at a couple, we want to understand why they are together. If we can understand that, it helps explain why we are together with whomever we have joined with. And often there is enough physical similarity, enough class similarity, enough atmosphere that emanates so that we do not have to study couples too long. There they are: usually matched in height, often matched in degrees of attractiveness. It has often been observed that as they get older, couples tend to resemble each other. Expression explains some of this, and compromising with each other's individual taste explains more. Without consciously realizing it, living with someone who is conservative can make one tone down one's excessiveness (if frustration does not provoke the opposite reaction and exaggerate it). The director of the status quo is usually willing to accommodate a few outtakes if the movie rolls successfully.

When couples present contradictions, however, we are generally puzzled and—if we know them—we begin to try to figure them out psychologically, to see what makes sense in terms of the exchange they have set up. In *Midnight Cowboy,* we have little trouble figuring out what Ratso is doing with Joe Buck; because fairy tales provide a framework for us, we can easily figure out what scruffy, street-urchin-thin Mick Jagger is doing with tall, blonde Jerry Hall.

But we are not always ready to analyze—to look for the psychological component—unless something seems off-kilter in terms of visual harmony. Then, if we cannot have our sense of the harmonious world verified, we open our other senses to attempt to create harmony on another level.

It is one of the inherent frustrations of art that the moment frozen in time may not be the significant moment at all. And the subject usually wants a definition that is not random. But without language, how does one person persuade another about something as abstract as, say, power? In part, because stereotypes of power depend on position, we can see hands on hips carrying meaning. But as any photographer or painter will tell you, more often the subject who has a preconceived notion of how to present himself or herself powerfully will look silly—a child teetering around in Mommy's high-heels.

What is it that makes people's attempts to create a strong persona fail when extreme seriousness informs it? In life, there are people who convincingly communicate strength by moving in close, making direct eye contact, leaning a particular way. So perhaps when they are painted or photographed in that way, what betrays them is time itself: they are choosing to stop; they are choosing, potentially, to be artificial. And the minute they acknowledge that, we look at them in a different, more serious way. Movement itself is dynamic; the individual is in a process of changing, reacting—still undefined. And while this may be calculated and studied (the impromptu remark recited with different inflections in front of the mirror an hour before it is delivered), we all tend toward the convenient assumption that we are reacting to our environment.

Vanity is a catchall word. Used in the pejorative, it lets us know that someone has focused inward to shut out the world. Used less judgmentally, it acknowledges a heightened self-awareness. Portrait sitters often describe themselves as feeling vulnerable. We are not supposed to move; we are in a light that we cannot control; gestures are ruled out (those that exist are frozen; real movement is ruled out). We know that something will emerge that cannot be erased—or even mitigated or augmented. What is happening is personal—an interaction between artist and subject—in an alien setting. It is both personal and instantly impersonal, and the two minds involved may be searching for very different things. Almost inevitably, the subject, who is self-

conscious, is on the defensive. Had Keats decided to write about people who were actually running in a circle, instead of figures to be freed only in the metaphorical sense, surely they would have been different people: possibly inhibited, perhaps show-offs, perhaps not willing to move in that configuration at all.

The process of being photographed or painted points out something that we do—or ask for—all the time: tips, cues, reassurance. In the introduction to Robert Mapplethorpe's *Certain People: A Book of Portraits,* Susan Sontag writes that "Most photography comes with a built-in claim for objectivity: that the photograph conveys a truth about the subject, a truth that would not be known were it not captured in a photograph. In short, that photographing is a kind of knowledge. Thus, some photographers have said they photograph best someone whom they don't know, others that their best photographs are of subjects they know best. All such claims, however contradictory, are claims of power over the subject."

So there it is: a process in which an individual who conceives of himself or herself having personal power is put into a relationship with a perceiver and chronicler who feels the same thing. It is the subject, though, who, for the duration of the artistic process, defers to someone who might well desire to be invisible, but who possesses near-lordly power. And when a couple is being photographed or painted, the artist has the task of judging not one person but two, and two not only individually, but as they interrelate. Usually, what becomes apparent when more than one person is moved into a frame has as much to do with sociology as with psychology.

Jennifer Bartlett explains the circumstances behind OUR EYES HAVE MET (plate 26): "He [Alex Katz] was over here for some dinner or party and saw Eric and me talking and just got the idea for the picture. So I think that what is interesting is the content of the picture verging toward the sentimental. The reality is that Eric was probably telling me I was too old to wear eye makeup. Or maybe there's a relationship beyond the one that Eric and I experience that Alex can see."

How much does Katz interpret? Anne Lyons says of ANNE AND BILLY (plate 23): "He never faces you with it. You face him with it. You're going to show it to him. Alex manages to be invisible. Alex never pushed us into that situation; we were pushing the situation at Alex."

Of his appearance in SUMMER TRIPTYCH (plate 16), Rackstraw Downes says: "Alex said, 'You've got to be touching. This is a painting about couples touching. I'm not going to tell you what to do.'"

Without being told, it is interesting what Katz's subjects mean to reveal. And it is interesting, as well, to see what they do reveal.

Roger and Sophie

Though it may seem an unlikely place to start a discussion of relationships, a look at ROGER AND SOPHIE (plate 20)—which is, certainly, rather humorous—may say a lot about the way in which we pair off and what that means about how we see ourselves and how others see us. In this painting the dog looks at the painter head-on. This is rare in Katz's painting: more often, we see eyes averted or cast to the side. Or we have the situation in OUR EYES HAVE MET where we are shown the moment that follows the moment in which eyes actually met. Avoided looks can be mysterious, or frustrating. In part, how we feel about them depends on how at ease we feel with the subject who is being portrayed and how secure we feel with ourselves.

The dog, with its lack of narcissism, may have an advantage not often found in Katz's paintings. This dog is unusual, attractive and plaintive in its forthrightness. We know Roger because of the dog, as well as we know Jennifer Bartlett in OUR EYES HAVE MET by the man who leans in front of her.

Here Roger's angular haircut calls attention to the artifice of our shaped hair. It is brought out even more by the dog's natural softness and shagginess—a dog that we could reach out and touch.

The dog is being a dog, and Roger—because he has summoned the dog—is allowing himself to be human and to be defined by the dog's presence. The dog is not a prop, but a definition—a way for the painter to get at his subject by portraying what his subject is attached to, and by showing how Roger relates to his dog.

Bathers

This is no let's-be-a-Christmas-card-and-face-the-camera couple (plate 21). They are painted in a moment neither terribly intimate nor uninvolved. The distance between them, in spite of the close proximity, is interesting: we seem to be looking more at an attitude of embrace—a gesture close, yet constrained—from which it is difficult to make a story. Except for his smile and some information about what they have been doing (the swimsuit and bare chest), there is no way to tell by the way they relate to each other what has really gone on before or what will come after. The viewer's eye is initially drawn to the man, Vincent. His smile lets us know something about him immediately, while we are not offered a glimpse of Anastasia's features. Although her hand is on his shoulder, Vincent's embrace seems firmer. He seems more involved in the moment than she is. He seems to have more power. On another level, we see some of the painter's attitude. The moment he has chosen to stop the action is tantalizing. Why don't they embrace? Or will they? It is as though, with their rectangular arms

and the horizontal lines of her bathing suit, they exist partly as geometry and as three-dimensional objects. The space below their waists, where their bodies have been cropped, makes them all torso. When we are directed to the upper parts of their bodies, do we follow along with the way they are presented, or think about the sexual aspects of this not-quite embrace? In spite of Vincent's bare chest and Anastasia's bathing suit, there do not seem to be many sexual overtones. Look at his squared-off fingers. The way his left hand has been painted makes the artifice of what he does rather obvious. Mannequins come to mind, and Man Ray's wooden figure. The mechanical and the use of geometric shapes seem almost an editorial comment on what is and what cannot be. *If* she moved closer, she would just be up against an ironing-board chest. Instead of thinking of the erotic implications of what a second could change (Meryl Streep's titillating nonkiss of Sting in *Plenty*), it seems a situation more analogous to the painful moment in Fellini's *Casanova*, when Donald Sutherland, obsessed with his own obsession, which has finally and sadly subsumed him, dances with the mechanical doll, who has become interchangeable with, or even superior to, a real woman. Katz's insistence on horizontal lines and geometric forms serves to slightly dehumanize the couple, and points out their limitations. Even the highlight on Anastasia's arm is not subtle or mysterious or there to point up the softness of her skin, but is rather extreme, isolated, a thing unto itself in the pureness of its shape. As the two of them connect, she casts a shadow on Vincent and Vincent casts a shadow on her, but even the shadows do not pool or suggest soft depth or sensual connection. Rather, we see the limits of what is transpiring. His eyes are closed, hers hidden. Usually such a situation would be an outtake rather than a direct moment, a tease rather than a fait accompli, yet here it seems to point up an essential lack of easy, sensual connection. In touching her—in putting his hand around her back and folding her toward him—his fingers become a geometric repetition of her rigid pattern. The other hand curves, but almost too delicately—no more a real hand registering real feeling than a hand from Madame Tussaud. It is a position reminiscent of a relaxed, casual touch, yet done too perfectly, too delicately, too artificially—a version of the gesture, rather than the gesture itself. In a way, this detail sums up the larger scope of the painting. We have a posture, not a real flawed position; we have the accoutrements of affection without any of the awkwardness or inexactness of one person grabbing another. Real romance too often consists of awkwardly bumped front teeth, of the hand meant to grab the other's that catches, instead, the wristbone. Vincent and Anastasia are in a pose of affection—nothing as strong as a parody of the act or even in a betrayal of themselves—but captured in a tame moment, a refined moment, a moment that does not resonate as more, but rather (considering the details and the technique) as

20. ROGER AND SOPHIE

24. The Thai Restaurant

23. ANNE AND BILLY

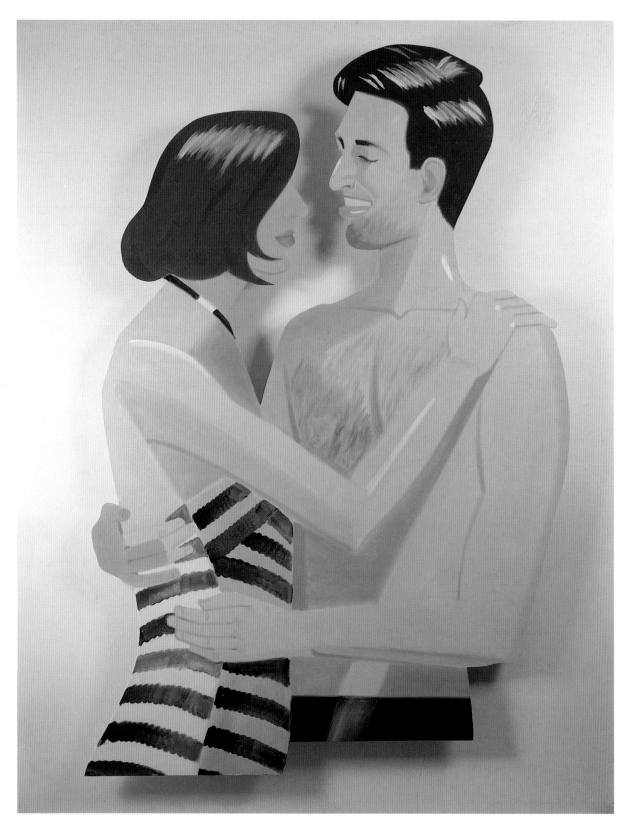

21. BATHERS

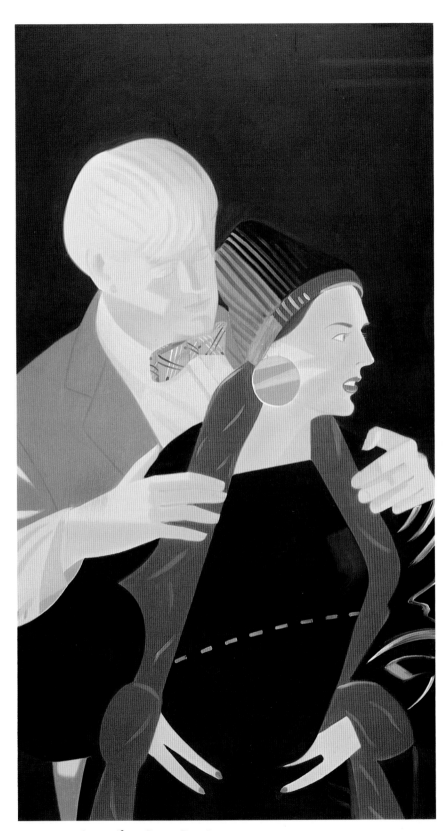

22. RED AND LIZZIE (from PAS DE DEUX)

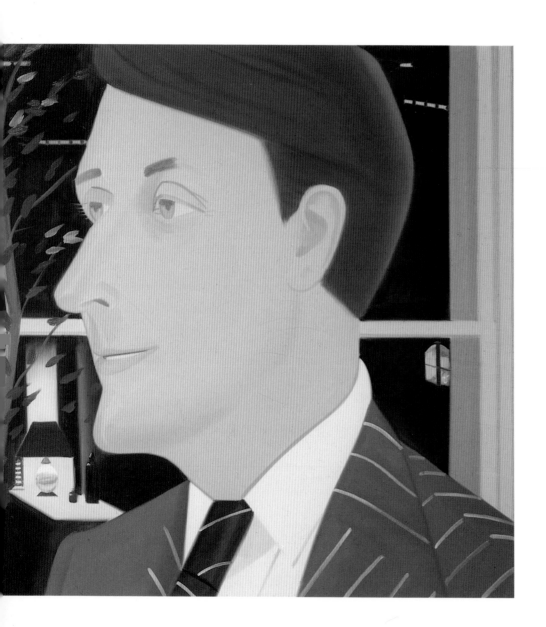

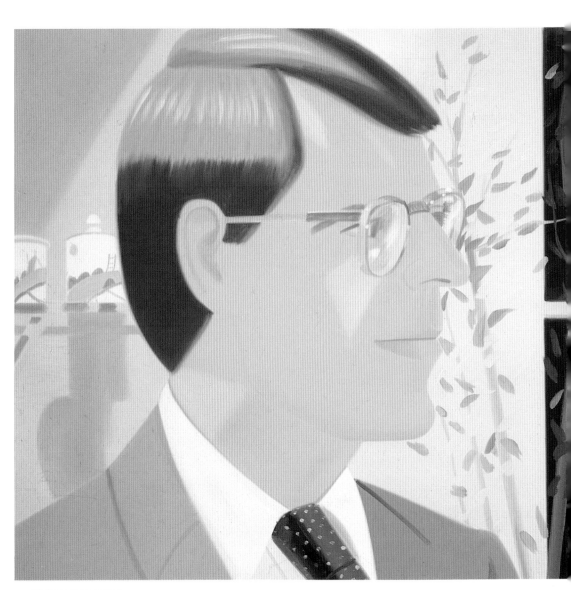

25. JOHN AND ROLLINS

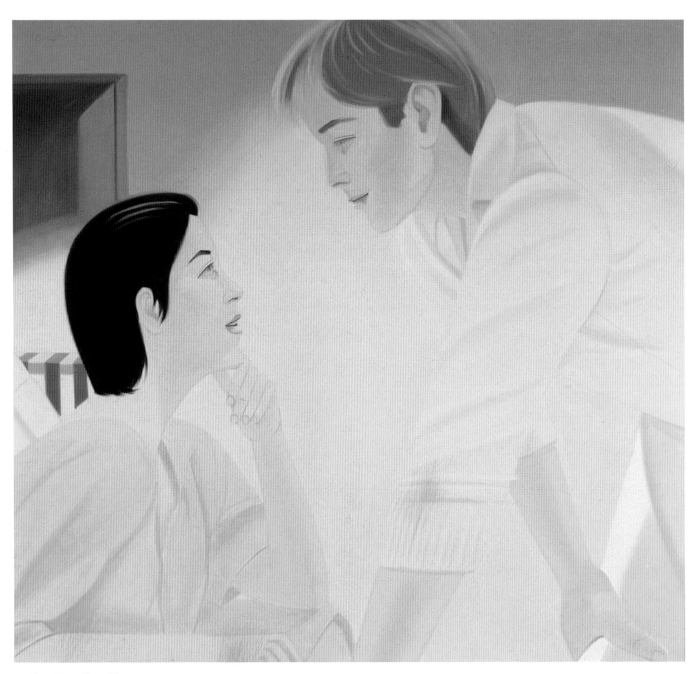

26. OUR EYES HAVE MET

less. Either consciously or subconsciously, the painter realizes the moment for what it is and acknowledges it: the stripes of the swimsuit do not match harmoniously, but meet awkwardly, imperfectly. The eyes of the couple do not connect, but have vanishing points different from the lights in each other's pupils. Perhaps Vincent and Anastasia have been stopped in time by the painter because he is interested in where they have stopped themselves. Light does not fall so regularly; patterns usually do not get so carefully scrutinized (except by seamstresses, who would have rejected this bathing suit); the human body (his hand) does not truly imitate inanimate forms. Things are too smooth here, too perfunctorily defined (the highlights). It is a missed moment, somehow—missed because of restraint, rather than awkwardness. They seem to have decided on something, and the painter is not projecting an emotion that does not emanate from the source. In technique and in composition, this canvas acknowledges limitation.

RED AND LIZZIE

In RED AND LIZZIE (plate 22) the people are more obviously postured than Vincent and Anastasia, while at the same time they seem to be more lively. In both paintings, the woman's attention is diverted or, as it is here, riveted elsewhere. Red has a more hands-on attitude; he seems happier or more sensually involved than his partner (though passively so; Vincent seems to be happy because *he* is happy; Red seems to be in a near-swoon that has nothing to do with Lizzie's emotions). Unlike Vincent and Anastasia, this couple melds physically; they seem like two people forming a joint entity, yet the fallacy of this is more immediately apparent because Lizzie is clearly concentrating on something that has nothing to do with the present situation. There is no way Red and Lizzie could be mannequins, moved together at some stylist's will, lit a particular way, with the correct measure of detachment superimposed. This portrait encompasses more overt complexity than BATHERS. More is at stake here. (This may always be true, though, when betrayals are obvious. Here Katz acknowledges that the couple is fundamentally out of synch. If they do not know this, the painter knows this, and the audience knows it.) Given that Katz is dealing with two people who are ostensibly united, but actually isolated, the problem becomes, in a way, his: to portray fairly, within an atmosphere electrified and determined by one person's preoccupation.

It would be impossible to argue that Katz passes no judgment on these situations as he paints. Though Lizzie may at first seem harsh (and active, as opposed to Red's swoon), her hands—much like Vincent's hands—are seen by the painter as her explanation and as her betrayal. They seem thwarted from touching; they are not painted naturalistically, with real potential for movement and touch, but as prehensile

85

claws. Can other fingers exist? Here, too, the hands seem placed—arranged—rather than the hands we ordinarily conjure up that have the power to squeeze. Along with this, Lizzie's clothes are fashionable, but also starkly simple. The diagonal turquoise line becomes the focal point, in spite of the fingers that should command our attention. This line dares to do something that Red and Lizzie can't or don't do: it is obviously erratic. The line—part of the pattern of the fabric the painter was presented with—echoes the solid stripe of light that falls on Lizzie's earring. How interesting that the solid stripe of light that falls on her adornment happens to coincide with the calculated randomness of an angular dotted line. One angle of light is meant by the designer to *seem* random, and another truly is. The artifice came first (we know, because Lizzie chose her clothes), and reality conveniently—and perhaps maddeningly—insists on a parallel reinforcement.

This portrait implies a critique; it goes further than BATHERS because a more dramatic, active moment has been settled on to portray. One person is lost in himself, and the other is preoccupied, even angry. Lizzie has a harsh look that, sadly, no touch, no other person's swoon, can temper.

ANNE AND BILLY

For the moment of the painting, there is no Anne and Billy (plate 23). Her almond eyes are exaggerated and almost virtually starry, as if she is lost in thought. She does not connect with Billy any more than Vincent, for all his seeming smiling openness, connects with Anastasia, or any more than Red connects with Lizzie, who is turned away from him in point of fact and metaphorically as well. There is an openness about Anne's face—the painter has come in much closer on this scene than on the previous two—with her hair swept back, her large lips perfectly colored. Her long neck and stylish dress with mandarinlike severity carry a hint of the ominous, though: the extreme decoration, the pointed collar increase our perception of her artificiality, and also of her remove from the casually dressed Billy. Her far-reaching swan's neck seems to truly remove her not only from herself—her own body, and what she wears—but from her companion. She is as emotionally removed from what she wears, her neck and head rising far above her collar, as she is from Billy. In her own right, she is lovely—composed, beautifully dressed, and in a world of her own, looking toward something out of view. What is Billy doing there at all? He is the blond flipside of her dark beauty, a person who embodies a different set of connections, who comes as a different archetype, even from another world. Yet he cannot—or does not—connect any more than she does. Here there is no meditative moment as there was with Red; Billy is merely a person who seems to have been moved into the frame, causing us to wonder, since

there is so little going on between the two of them, and since she clearly predominates, what would be lost if he did not happen to be there at all. Might she be as preoccupied, as wistful as she is, without him? We would expect less if this had been acknowledged—if the painting had been titled LOOKING IN TWO DIRECTIONS. Even without that easy summation, though, what the painter has captured is obvious: he has found opposites, emotionally and physically. And once again we see that proximity is no real foundation for personal attachment. There is a real rapport, a real coupling, of Roger and his dog that exists nowhere in these other paintings. What Anne knows or wants is mysterious, but the fact of her wanting it is no mystery. Billy seems to exist to embody a presence that is extraneous except that it points up her longing. The implied comment on the relationship is obvious, and the props (her costume) and positioning reinforce the gulf between them. Anne looks into the light. Billy is shadowed. In subtle, visual ways, they have something in common: the deep V of her collar is echoed by his open-collared shirt. The small wisps of hair that are brushed back against her ear—the softness and irregularity amid her perfectly sculpted hair—echo his textured, imperfect hair. Yet they are worlds apart: physically, emotionally, in space and time—though they are placed together at the same moment.

There is, of course, no one moment: it is her moment; it is his moment. It is only the painter who has stopped to see how clearly those moments do not coincide.

THE THAI RESTAURANT

Nothing but the title tells us that the couple depicted here is in a restaurant (plate 24). Again, it seems that the background or the possibilities of what is going on around them could help define the people, but Katz omits such details as mere facts, insisting on the dynamic of the couple to tell us what we should know. As is often the case with the couples he paints, one person seems more dominant, more energetic. The way the woman is sitting, and the way Katz has positioned her in the light, forces us to look at her first. She seems alert and composed, whereas the man is slumped and preoccupied. The couple's emotions do not mesh in the moment. The space across a restaurant table divides them as surely as a real barrier would. We are often divided from one another (a restaurant table is an ordinary, everyday barrier), and the way we surmount barriers is usually through our intensity: eye contact; inclining toward the other person. The moment in which Katz has chosen to paint this couple, though, is not a moment of connection between them. It is a moment, in the manner of OUR EYES HAVE MET, when the way the woman looks toward the man suggests and acknowledges that they have a shared history (although the other person seems oblivious to it). The painter seems to follow through with the man's mood in the way he has positioned

him: he is not only passive in attitude, but he is less wholly painted, less completely presented than his companion. The impassivity of his face is troubling. But what can we know about him? We can only know what he might be thinking if we guess, but we can see what he is not responding to. In fact, he is in part defined by the woman's gaze and his lack of response to it. Statuelike, his body slumped so that he seems heavy, he is in a world of his own—a world undefined by the time in which he exists, or by the place, or even by the world outside the restaurant window.

The airy brushstrokes of the plant that grows behind the couple direct our eyes up and over to the woman's side of the table—away from the darkness and toward the light. The plant exhibits grace and movement as it spills toward her, and serves to subtly intensify our perception of him as rigid and uninvolved. Similarly, the two pinpoints of light keep our attention on the woman and on the world outside her portion of the window. The star-shaped pattern of her dress unites her with the outside world that we do not see in detail, the same way the feathery leaves behind him point up the artificial rigidity of his striped tie.

The longer the painting is viewed, the more the contrast of the delicacy of the plants with the divided vertical glass panels of the door suggests a loveliness. Our eye is constantly drawn to the leaves, and to the world beyond them. The details of that world are a mystery—where the couple has come from to get to this point is a mystery—but the couple themselves are mysterious only in terms of specifics: she is thinking something he is not thinking; she is more sensual (the brushstrokes of the little line of light lead our eye to her lips); her eyes are flecked with light, and doe-ish. The fragile leaves behind her head seem like antlers, or like some sort of crown. Potentially she is capable of springing into action—even a little sparkly and magical.

Why are they in a Thai restaurant? Perhaps because it has some exotic potential that they are not responding to. Perhaps because we need not think of them in a real place at all, but rather concentrate on their different attitudes, and on the paradox of the man's passivity in spite of his proximity to the possibilities she holds out. We are again looking at a missed moment—a moment out of time—a moment in which human players sit differently, their feelings keeping them remote from one another. Their attitudes are clearly in contrast, just as the feathery tree exists in contrast to the nearly amorphous darkness outside.

OUR EYES HAVE MET

In contrast to THE THAI RESTAURANT, the couple here seems in a common nimbus (plate 26). Everything about the scene is relaxed: he leans forward as if it takes no real strength to balance; she touches her fingers to her chin, but lightly—not really need-

ing to support her head. His posture, which normally indicates power (as her being seated, gazing up at him, might be considered more passive) is, instead, relaxed enough that we understand it to be the result of rapport instead of rapaciousness. These are people we might glance at across a room and understand almost immediately; we would probably assume so much, so immediately, that we would not need to study them. In a way, they are pleasing prototypes—and perhaps that is part of the reason we assume a narrative about them: we know, essentially, what they are feeling; we can guess that they have a common history; we can imagine that the follow-through of this moment is one of affection. Though stopped in time, the painter has rendered them so that they do not seem stiff. Because of the way she looks at him, and the way he inclines toward her, we suspect that movement is about to take place. She might blink or smile. He might bend forward to kiss her. It is a painting that portrays people in some pleasant, ongoing process.

We may look at OUR EYES HAVE MET and smile because of a similar remembered moment, or we may even pause to construct an imaginative narrative, but basically what is being triggered is an empathic reaction with something, as opposed to our wanting or needing to be involved in a particular scenario. However specific this painting is, what we are responding to is the people's state of mind. The particular couple here doesn't matter; almost any two people who felt this way would suit Katz's purpose as well.

The slight missed connection between their eyes has nothing to do with the missed connection (or, rather, nonconnection) of THE THAI RESTAURANT and nothing to do with the missed connection that Lizzie so vehemently enacts in RED AND LIZZIE. The figures are stand-ins for an attitude, for a state of mind—and to that extent they are actors with whom we can share something in common. They may even be guideposts, of sorts, for where we have been or where we will go.

OUR EYES HAVE MET is best taken not as naturalistic, but as painting done in a naturalistic manner that is meant to resonate symbolically. Abstractions (love, intimacy) are difficult to convey without some narrative, and the near-photographic freeze-frames that Katz is so fond of have to rely more on archetype and symbolism than on a consecutive narrative, acted out or defined by the order in which it is presented. Katz has more in common with the staccato vibration of poetry that must, in its compactness, resonate intensely what has been distilled.

While Katz could conceivably have seen the couple in OUR EYES HAVE MET in a room and photographed them, getting a photograph resembling his finished painting, the medium here changes the message. In a photograph, this would either be the result of capturing the perfect moment or clicking the shutter closed so that the pho-

tographer had an outtake (his eyes might have met hers one second before the picture was taken). With a photograph, we wouldn't know. Because Katz considered the essence of the situation and interpreted it to be this—because he chose this moment to paint as opposed to any other—we have at least one mystery solved: what the artist's attitude was when he painted it.

JOHN AND ROLLINS

As with the couple in OUR EYES HAVE MET, Rollins in JOHN AND ROLLINS (plate 25) seems to be standing under a spotlight. His face is defined by the way light falls on it and forms pale patches, while John's face is defined by an evenness of light that results in a clarity of skin tone, with only some shading beneath his eyes. Rollins's face is seen as a surface that catches and registers light; his world, too, is a brighter, clearer world—perhaps nothing to make anything of, except that it is in close proximity to John's world, with the nighttime world outside his window. The tree is the crucial unifying element. Though it is possible that Rollins's tree is not John's tree, Katz has painted the two canvases as though the tree moves through time. In firing off a few pale green leaves, it encroaches on the other portrait and becomes a part of it. We know when we see it that it is a tree in the background, but this is because of the way we are used to looking at perspective—our preconditioning. It is also what divides Rollins and John, in terms of sensibility. Katz has played a little game in which the tree has potential movement while Rollins's world and John's world remain distinct, divided by the vertical line where the world of light ends and the world of darkness picks up. Although both men are conventional—well-groomed, neat—they are conceived of quite differently by the painter. Rollins is clearly a composite: he has a head on which light falls, so that by observing detail, we think of him as put together, composed. No specific source of light falls on John: the skin tones are even, smooth. No action is happening or registering on his face.

The tree makes the transition between Rollins and John, which they do not make themselves. They are, of course, different people, at different times and in different environments, so there is no reason why they would be connected, yet Katz has chosen to link them—to join them, and to divide them. He has linked them on the basis of surface sameness, yet, as we quickly see, the mood of each is different. There is less of a mystery about Rollins than about John. And though they resemble each other, the surfaces of their faces differ in how they function as receptors of light. Though the suits are similar, they do not function to make any real connection between the two men. Katz might have posed both men so that they would be joined on one canvas, but instead he has brought two canvases together to suggest—and then

90

to deny—a link between the two. In the same way that pieces of Roseville pottery might be lined up and photographed for a catalogue (objects recognizable as created and informed by the same idea, with surface elements in common), the painter has lined up two human beings with certain surface similarities and shown that this finally means nothing. Roseville pottery is one matter, and human beings are another. There is something unsettling about the fact that resemblance between people does not necessarily carry any more meaning than the way water lilies bulge from Roseville vases.

If nothing else, JOHN AND ROLLINS shows us that surfaces do not define the individual, and neither do they provide a forum for interaction. The suits are only a surface link, the well-groomed appearances only a custom, and not much of anything can be known about the individual lives of Rollins and John except that the painter has interpreted for us that their lives, at the moment of the painting, do not coincide. By dividing the painting, Katz has arranged this to be so. Here Katz tampers with time and space, but even when couples do pose together, they enact separateness. Katz merely paints their polarization (Red and Lizzie; Vincent and Anastasia). The tree— the Fairfield Porterish tree—is almost a prankster. Since it is not the same world, how can the tree on Rollins's side shoot its green leaves into John's world? If the tree can make a transition, how is it that Rollins and John do not? Think of the tree as an "if only"; what should move, really—what should move and connect does not. And while it is commonly accepted that trees are brought in out of nature to decorate and to humanize offices, here the tree seems to be functioning more humanly than the two subjects. We would accept it as mere decoration had we not had its movement—its potential—painted for us; we would accept John alone had we not seen him in the painter's context as a person who might be with other people. Katz has put Rollins and John together only in a superficial way by their positioning; Rollins and John, we are led to believe, would in any circumstances remain distinct, in spite of what they might appear to share.

Katz's point, finally, is that as frustrating as it may be, one world is one world, and each person is a person unto himself or herself. In contrast, the artist Robert Longo believes in suggesting explanations. He believes in event—in some consolidation of meaning that takes place off canvas. Of course Katz can't make mood literal, but he concocts no external correlative. It is as if scenarios explain nothing beyond whatever their psychological dimension connotes. Like Beckett, Katz has always been more interested in raising questions about what is meaningful and, by implication, how to live, than he is in attempting to offer interpretations of reality.